CHICAGO'S LOLLAPALOOZA DAYS
1893–1934

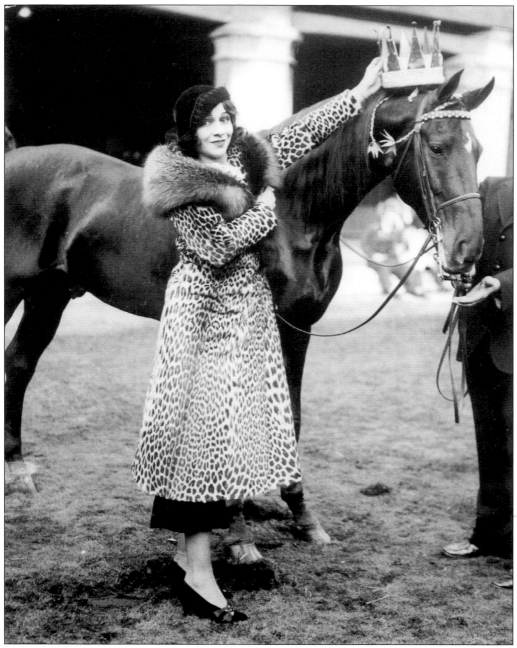

ROYAL HORSE: Famed Chicago-born opera singer Coe Glade poses with equine royalty at the 1933 World's Fair. (Author's collection.)

ON THE COVER: Clockwise from top left: Six-foot-plus Chicago opera star James Goddard with a local circus midget (author's collection; see page 45), Coe Glade crowning a horse at the 1933 fair (author's collection; see above and pages 39 and 112), postcard portraying Chicago as a heavy-drinking "Porkopolis" (author's collection; see page 24), Ralph Dunbar's touring vaudeville musical troupe Clown Land (author's collection; see pages 64 and 65).

CHICAGO'S LOLLAPALOOZA DAYS 1893–1934

Jim Edwards

ARCADIA
PUBLISHING

Copyright © 2019 by Jim Edwards
ISBN 978-1-4671-0370-1

Published by Arcadia Publishing
Charleston, South Carolina

Printed in the United States of America

Library of Congress Control Number: 2019939525

For all general information, please contact Arcadia Publishing:
Telephone 843-853-2070
Fax 843-853-0044
E-mail sales@arcadiapublishing.com
For customer service and orders:
Toll-Free 1-888-313-2665

Visit us on the Internet at www.arcadiapublishing.com

Dedicated to my wife, Wynette.

CONTENTS

ACKNOWLEDGMENTS

So many excellent books have been written about Chicago that one must ask, why is another needed? The answer is that there was no publication featuring Chicago's two World's Fairs as bookends to four decades of the city's true Lollapalooza days. After completing this book, I noted that many of the issues during this time span, the 1890s to the 1930s, are still being talked about today. Chicago has changed over the years, but big cities seem to retain their core nature.

All images, unless otherwise noted, come from my personal collection. They are photographs, glass slides, prints, postcards, and stereo cards purchased from dozens of dealers in vintage images and ephemera over the years. Background information for the written narrative comes from reading over 60 books written about Chicago published over the centuries.

I would like to thank Jeff Ruetsche and the production editors at Arcadia for their terrific work in bringing this book to life.

INTRODUCTION

In the past, Chicago has been called many names—That Toddlin' Town, the Windy City (for its politicians, not weather), and Chi-Town, to name a few—but Lollapalooza Land would work as well as any for the period from 1893 to 1934. The word was used by a Chicago Democratic leader to describe a grand, rowdy costume ball, held for the first time in 1908 in the Chicago Coliseum. It was billed as a fundraiser for the Democratic Party, which controlled the office of mayor and all important elected officials in Chicago. At the affair, the Chicago liquor supply was exhausted—thousands of bottles of champagne were consumed as well as almost 30,000 quarts of beer. Music, food, and drink ruled, and all Chicago showed up to party. Michael "Hinky Dink" Kenna, one of the two aldermen from the powerful 1st Ward in attendance, was quoted by the press as saying that the party was a "lollapalooza." The gatherings continued for several years, and each year, they grew wilder and more disruptive.

The love of partying seems ingrained in the Chicago character. These years between Chicago's World's Fairs, when partying ruled, are full of stories and events that are worth resurrecting along with pictures relating to these events.

One grand example that took place at the pinnacle of these Lollapalooza years was captured by the *Chicago Tribune's* Robert Hardy Andrews, whose writing style was captivating and humorous. An eyewitness story from his biography illustrates his gift for catching Chicago lollapalooza:

> Midnight on New Year's Eve, 1932, Lady Godiva [Helen Gould Beck, aka Sally Rand] rode a white horse across Michigan Boulevard clad only in a snowstorm. She was expected at the Artist's Ball across the street and would have been there on time if there was any way to ride a horse through a revolving door, there was not, and none of us knew how to get the door off its hinges. The wind howled in from the Lake. Lady Godiva turned blue to match the color of her comments, her horse tired of capering costumed celebrants, headed for his warm barn in Lincoln Park, Lady Godiva fell off, but was caught by willing hands. There was a lot of pull-and-haul, before her victorious bearers carried her, above their heads, into the hotel ballroom . . . [once there] Lady Godiva fled, breaking the world's record for the high-hurdles dash to the powder room.

What happened after this event is fascinating. The 1933 World's Fair, which sponsored the ball rather than risk a lawsuit from Beck, signed her up to be a fan dancer at the fair! At the fair, Beck was arrested four times in one day by police for indecent behavior.

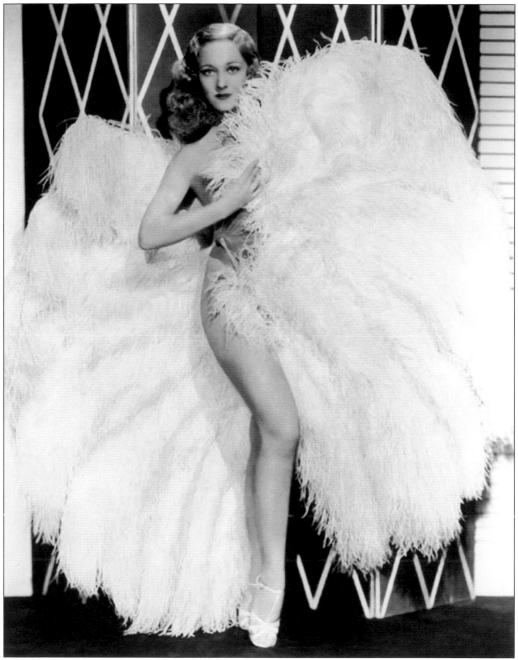

SALLY RAND'S FAN DANCE. Seen here in 1934, Sally Rand, with her world-famous fan dance, was the perfect capstone to Chicago's Lollapalooza years. Rand, whose real name was Helen Gould Beck, was a former circus acrobat and silent film actress who had become a popular draw at Chicago's burlesque clubs for performing her risqué fan dance. Using ostrich feathers and body paint, as well as long underwear at times (so it has been said), her peek-a-boo performance only gave the illusion of nudity. It caused quite a stir when she was asked to do it at the 1933 World's Fair. She also did a bubble dance and performed these acts into the early 1970s. (Library of Congress [LOC].)

One

THE LOVIN' LEVEE

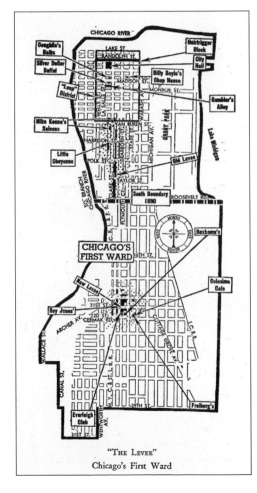

"THE LEVEE"
Chicago's First Ward

THE LEVEE. At one time, Chicago was called "White City," but between 1893 and 1934, a more accurate title would have been "Red Light City" because of prostitutes, pimps, thieves, and murderers. Stories of these wicked lives make for interesting reading. Even as sin ruled during these decades, reforming and cleaning up were in the air. City politicians talked change out of one side of their mouths, but the other side wanted to keep the good times and bribery going. And it all started in the city's infamous 1st Ward, also known as the Levee District.

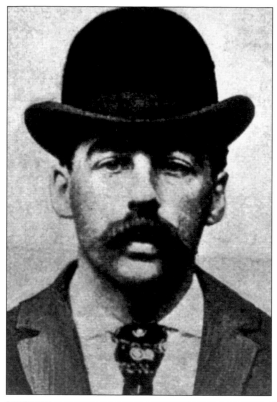

H.H. Holmes. A mass murderer, much like Jack the Ripper, stalked the 1893 World's Fair. His name was Herman Webster Mudgett, but he called himself H.H. Holmes, a tribute to Arthur Conan Doyle's Sherlock Holmes. Mudgett was a liar and insurance con man who killed many children, young girls, and men in Philadelphia and then moved on to Chicago. While in Chicago, preying on fair visitors, he may have killed as many as 200 people or as few as 9, according to local newspapers.

Murder Castle. Holmes operated out of a three-story complex, which he promoted as a boardinghouse three miles from the fair. Newspapers dubbed his hotel the "Murder Castle." The ways in which Holmes murdered his victims seem like a gory Edgar Allan Poe tale. The rental rooms were attached by a honeycombed series of trapdoors, secret passageways, and torture chambers; dozens of tenants—almost all women—never left. The vacant building is seen here in the early 1900s, before it was torn down.

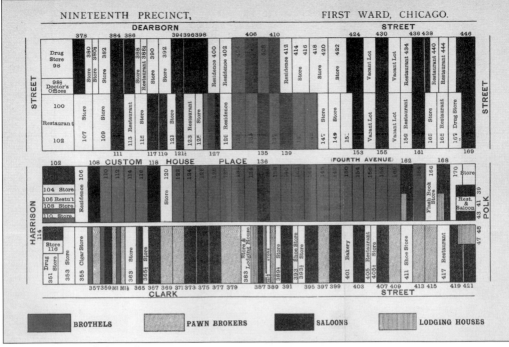

DEN OF VICE. While Holmes went about his murders on the South Side, red lights were shining just a little north in a district named the Levee. This hotbed of brothels, saloons, and dives centered on Clark, Polk, and State Streets just north of the Dearborn Station.

HIGH PROFITS. The brothels stood side by side along the streets, with interconnecting basement passageways. Mrs. Schlotter, a brothel madam, noted that her six girls once serviced 394 customers over four days. Their Olympian efforts earned them $98.50. Florence was the all-star, with 45 customers in a single day.

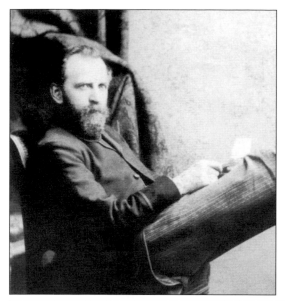

REFORMER W.T. STEAD. The early 1890s saw the beginning of interest in curbing rampant prostitution in Chicago. The chief advocate of reform was English journalist W.T. Stead, who visited the 1893 fair and imbedded himself in the Levee for months. Stead made friends with many of the madams in the Clark Street surrounds. He studied public records and discovered that many of the brothels were owned by Chicagoans of wealth and position—the same people who filled their homes with respectable nude paintings by Pierre-Auguste Renoir! Stead decided to write an exposé book on his findings and called it *If Christ Came to Chicago*. The exposé was published in 1894, and as Stead became a popular speaker at civic functions, the newspapers smelled headlines.

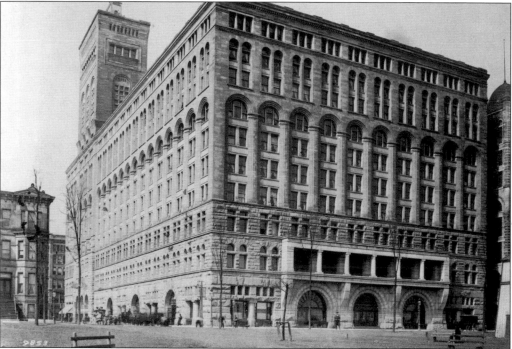

SCENE OF THE CRIME. The *Chicago Herald* sent police reporter John Kelley to make a copy of the unpublished pages of the book, which was held under lock and key in Stead's office in the Auditorium Building. In turn, Kelley paid Stead's assistant Edmund Brown $50 to open the door to the office so that Kelley and reporter Charley Seymour could copy crucial pages. All this happened while Stead was the guest speaker at the Chicago Commercial Club. The *Chicago Herald* published material from Stead's upcoming book, and the public went crazy. The reform movement in Chicago now had all the city newspapers joining the bandwagon to kick the devil out of town. Stead had helped birth the Chicago reform movement and made himself the world's first investigative reporter. He died tragically, a passenger aboard the doomed *Titanic* in 1912. (LOC.)

LUBED-UP LOVERS. Drugs and liquor were the lubricants of these fun-loving days. The prostitutes' stamina came from drugs available in local pharmacies and on the street. Users, called "air walkers," were full of cocaine, morphine, morphine-sulfate, and liquor. A song of the day told of "Cocaine Bill and his lover Morphine Sue, romance in the Levee." Some morphine was synthetic, sold under the trade name Dr. Birney's Catarrhal Powder.

On STATE ST., CHICAGO. 1901

THAT GREAT STREET. Saloons along State Street were so numerous that the street was called Whisky Row, the city's first magic mile. Music filled the air to help keep customers happy in the saloons and brothels.

13

JIMMY AND JIMMIE. Music was usually provided by a house manager called the professor, usually a black performer on the piano. These skilled ivory-ticklers played many styles of piano—classical, popular, blues, and perky ragtime. They were highly paid at $10 a week. Ragtime music brought in the young people. Most legendary was the pianist Jelly Roll Morton. Another famous musician was Lame Jimmy, who played at Carrie Watson and Vina Fields's brownstones at the time of the 1893 fair. Lame Jimmy was so popular that many 1st Ward Democratic Party fundraisers were held to benefit him in the 1890s. Jimmie Noone, seen here in Chicago in 1920, was a terrific clarinetist and saxophone player. He directed Jimmie Noone's Apex Club Orchestra, one of the city's most popular jazz bands in the 1920s.

SLIPPED A MICKEY. Saloons next to the brothels had 5¢ beers and free lunches. In 1896, Mickey Finn had a saloon called Lone Star where he concocted a little drink that would drug his customers, making them ripe for being robbed. He named the drink after himself.

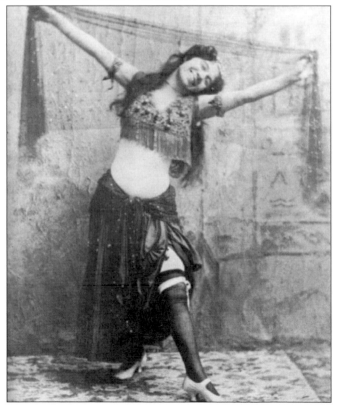

LITTLE EGYPT. The saloons and brothels used all kinds of things in their windows to attract attention. In 1904, the Senate Tavern in the Levee featured Little Egypt, a dancer from the 1893 fair, demonstrating her shake and shimmy.

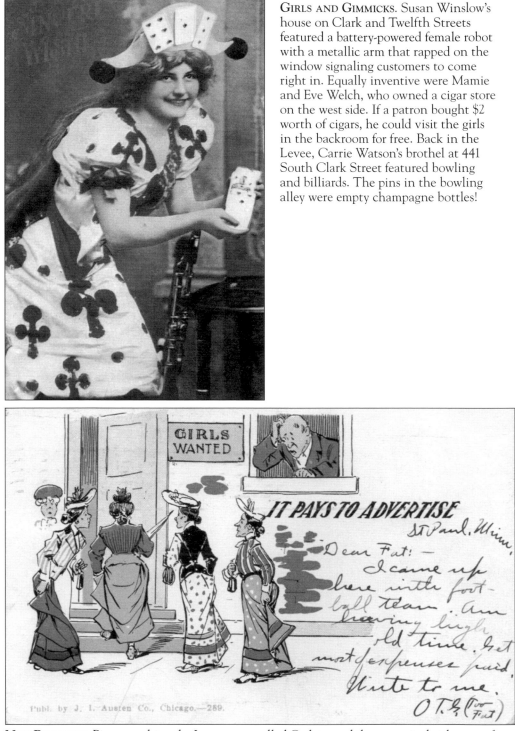

GIRLS AND GIMMICKS. Susan Winslow's house on Clark and Twelfth Streets featured a battery-powered female robot with a metallic arm that rapped on the window signaling customers to come right in. Equally inventive were Mamie and Eve Welch, who owned a cigar store on the west side. If a patron bought $2 worth of cigars, he could visit the girls in the backroom for free. Back in the Levee, Carrie Watson's brothel at 441 South Clark Street featured bowling and billiards. The pins in the bowling alley were empty champagne bottles!

NEW RECRUITS. Pimps working the Levee were called Cadets, and they recruited girls, some from local department stores, such as Marshall Field's. The low wages for young female clerks made them easy prey for fast-talking pimps.

UNSUSPECTING PREY. The nearby Dearborn Station, seen here in 1910, also provided plenty of innocent young girls from out of town for the taking. Fourteen-year-old Margaret Smith from Benton Harbor, Michigan, was recruited by pimp Frank Kelley and put into his brothel on Clark Street. Kelley's real name was Alphonse Citro, and his house's customers were all Italian. Smith escaped with the help of a young barber, but she was recaptured. Kelley noted, "I'm losing money every day she is gone." Chicago police arrested Kelley and freed Smith. Kelley was sentenced to one year in jail for pandering and fined $500. Kelley escaped to Italy. In the two years after the Kelley case, US district attorneys tried 2,509 "white slavery" (prostitution) cases. (LOC.)

RARE VIEWS. One of the headquarters for this sex slavery was owned by Maurice Van Bever and his wife. They ran two houses, the Paris Brothel and the San Souci, which backed up to each other. The madams came up with clever advice for their girls: "Be intimate in your loving, but never familiar—when you fart, lean your ass off the bed." Pictured here is the Paris Brothel at 2101 Armour Street.

EVERLEIGH CLUB. The multiracial Levee had its own mayor. Mayor Pony Moore was black and ran a saloon called the Turf Exchange. Unfortunately for him, his reign was shortened when he had a run-in with the Everleighs. The Everleigh sisters owned Chicago's most prestigious and cozy upscale brothel, the Everleigh Club, seen here at 2131–2133 Dearborn Street. Moore tried to prove that Marshall Field Jr. was shot by Minna in their club and then taken to a more respectable place to die. The sisters won the battle of words, and Moore lost his leadership.

EVERLEIGH SISTERS. Ada and Minna's real last name was Sims, but they took the name Everleigh as a tribute to their grandmother, who ended all her letters with "Everly Yours." An evening's entertainment at the sisters' house in today's money might have run as much as $5,000. Time for girls was billed out at $50, and a meal cost the same. The sisters' mansion had gold everywhere: spittoons, plates, fish tank, and player grand piano. Their credo was that a $50 client was more desirable than five clients at $10—less wear and tear.

HARRISON CRACKS DOWN. Their playboy club attracted famous Americans and foreign nobility to Chicago. Minna decided to issue a leather-covered brochure in June 1911 to call attention to South Side Chicago's many attractions, including their own club. The brochure was sent out locally and throughout the nation. Mayor Carter Harrison Jr. saw the brochure and considered it demeaning. The Everleigh Club was uncharacteristically shut down by Harrison, who was renowned for turning a blind eye to, if not encouraging, the city's vice district, on October 24, 1911. The sisters departed to New York with millions and became society leaders there. Harrison, whose father had been mayor, served from 1897 to 1905 and again from 1911 to 1915. The Levee District and all its debauchery had blossomed under his watch.

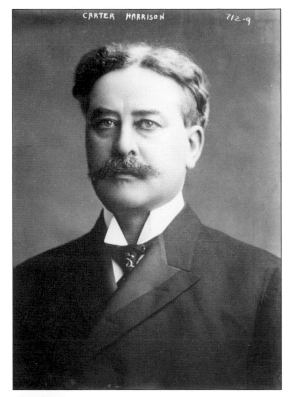

QUEEN OF VICE. Before the Everleigh sisters arrived in Chicago, Victoria "Vic" Shaw was known as the "Queen of Vice" in the city. Vic fought the sisters and even outlasted them in business, not closing her last brothels until 1938. She had tried to pin the Everleigh sisters and their prostitutes with murder accusations, but nothing stuck in court. In 1941, Vic found herself in federal court, facing a narcotics charge.

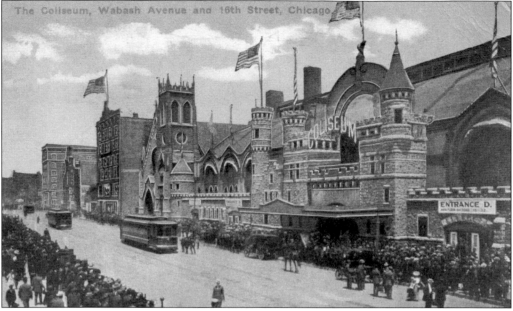

The Coliseum, Wabash Avenue and 16th Street, Chicago

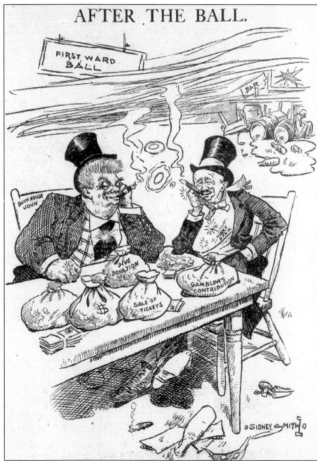

AFTER THE BALL.

LOLLAPALOOZA! Michael "Hinky Dink" Kenna and "Bathhouse" John Coughlin, 1st Ward political bosses, took the out-of-control frivolity up to a new level in 1907. These two dandies decided to throw a costume ball to benefit the 1st Ward at the Chicago Coliseum, pictured above. Kenna owned a saloon on Clark Street across from city hall, called the Workingman's Exchange. He and Coughlin became not only lords of the Levee but of Chicago as well. Hinky Dink entered the ball colorfully dressed with an Everleigh sister on each arm. He was quoted by the press as saying this party was a "lollapalooza." By the end of the shindig, Chicago's liquor supply was exhausted. The last ball, held in 1909, was a drunkards' parade; 10,000 magnums of champagne and 35,000 quarts of beer were consumed. *Chicago Tribune* cartoonist Sidney Smith captured notoriously corrupt Kenna and Coughlin in the whimsical cartoon at left, "After the Ball."

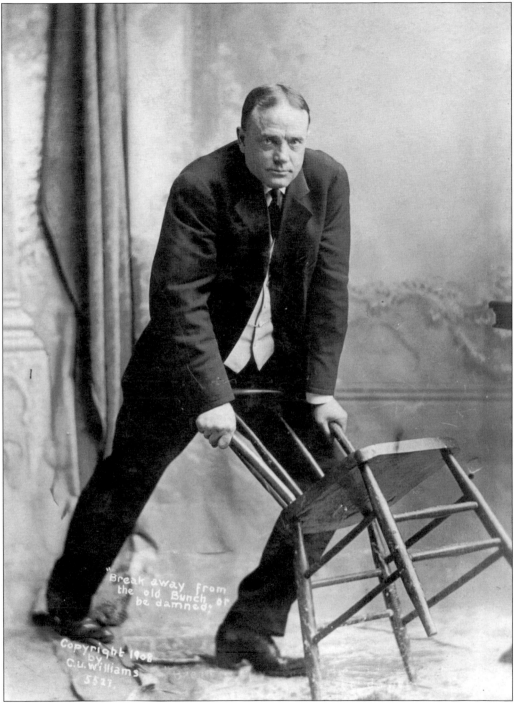

Pitching Reform. W.T. Stead was no longer alive to champion reform in the new century, but Billy Sunday, former Chicago White Sox player, put up his mitt and replaced it with a Bible. He kept his slide into home plate for drama when preaching. Sunday went after sex pretending to be art. In the inscription on this photograph, he warns those engaged in it: "Break away from the old bunch or be damned."

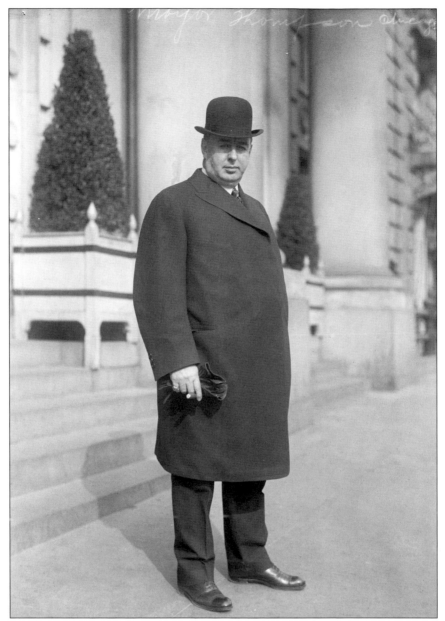

BIG BILL THOMPSON. The glory days of the Levee were threatened with the arrival of Prohibition. Chicago voters let it be known what they thought of the Volstead Act of 1920 by voting three to one against it. Still, Mayor William Hale "Big Bill" Thompson, seen here, named a new police chief, Charles C. Fitzmorris, and instructed him to clean up the city. He passed the buck to his chief detective, Mike "Go-Get-Em" Hughes. Hughes and the police arrested 800 men and women from saloons and dives run by the town's most famous crooks—"Prince Artie" Quinn, "Hot Stove Jimmy" Quinn, "Lovin' Putty" Annister, "Nails" Morton, and "Izzy" Lazurus. Fun times were almost put out of business. Nicknamed "Big Bill" for both his size and his over-the-top personality, Thompson served as mayor from 1915 to 1923 and again from 1927 to 1931. He proposed a municipal pier on the lakefront to attract tourists, and pledged to wipe out Chicago's lollapalooza image, but the partying continued. (LOC.)

Two

POLITICS AND POLICE

THAT TODDLIN' TOWN. Control
of Chicago in 1893–1934 rested in
the hands of politicians, and their
police. They in turn were subject to
the will of the voters, who mostly
favored an open free-for-all. This
behavior was beautifully captured
in the lyrics of a in 1922 song
by Fred Fisher called "Chicago."
Fisher subtitled his song "That
Todd'ling Town," a perfect adjective
to describe Chicago. The *Chicago
Tribune* in a June 18, 1997, column
written by Mary Schmich defined
the word as a mix of childish
and sophisticated behavior.

PORKOPOLIS. Early on, Chicago thrived on pigs and prostitutes; in fact, the city was once called Porkopolis. Beef and pork slaughterhouses on the South Side provided thousands of jobs and made Swift Company and other meat-packers rich. The tavern at 420 North Dearborn Street used a trading coin that had a pig's head on one side and a pig's tail on the back. It was a perfect coin to flip to settle arguments—"Heads I win, tails you lose."

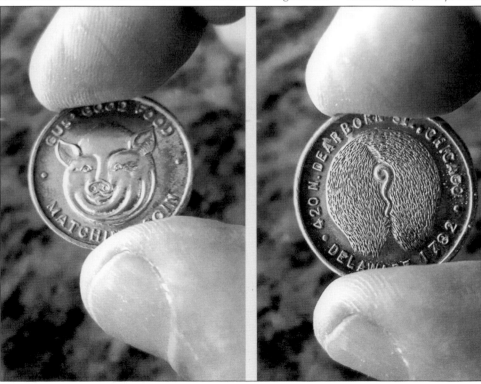

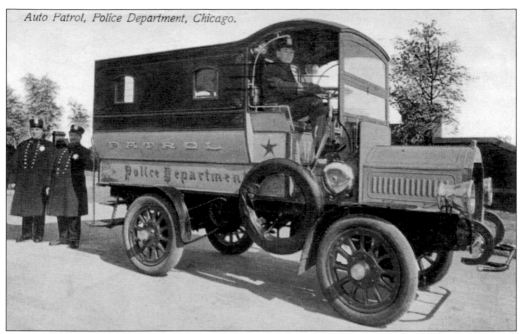

Auto Patrol, Police Department, Chicago.

PADDY WAGONS. Police walked the streets to protect the public, and that public included prostitutes and drunkards. When these individuals proved dangerous to themselves and others, they were taken to jail in "Paddy" wagons. These wagons were so named in reference to the largely Irish Chicago police force, which included many men named Patrick.

CHICAGO TYPEWRITER. In quieter times in Chicago, prior to gangsters, the only tat-tat-tat sounds were from typewriters in office buildings. But after World War I, the streets resounded with the deadly rat-a-tat-tat of machine guns of Chicago gangs fighting over turf. In fact, Chicagoans called machine guns "the Chicago typewriter." Frank McErlane was said to be the first mobster to use a machine gun during the bootleg war in Chicago. As this 1920s newspaper advertisement shows, police forces were using them too. Everyone in Chicago needed protection or help of some sort; they often relied on a sponsor, also known as a "Chinaman," to help secure employment.

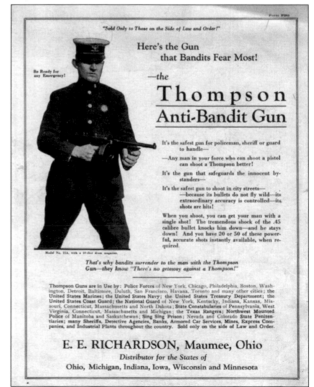

TAVERNS AND POLITICAL CONTROL. An early political force at the turn of the 20th century was Michael Cassius "King Mike" McDonald. His popular hangout tavern was at Clark and Monroe Streets and was called "the Store." The Store was the base of control of the 1st Ward, and therefore, the entire city. King Mike, not P.T. Barnum, came up with the expression "There is a sucker born every minute." The press in Chicago lampooned him as a tiger on the prowl, and so he was. His tavern served up thousands of beers each week, no doubt with hamburgers and boiled eggs. This tavern, pictured in 1911 at Twelfth and Wabash Streets, was a typical 1st Ward establishment of the era.

ALIEN INTERESTS. Sometimes, the powerful Democratic machine in Chicago had to defend itself from outside crooks. A New York City slicker, Charles Tyson Yerkes, convicted in New York of larceny, came to Chicago with $40,000 to invest. With this, he got control of the streets in Chicago. Yerkes built a railway system above the streets, which came to be called the "L." The L was extended to Jackson Park in time for the 1893 fair. Yerkes sent forces to Springfield to bribe the legislature to pass the Allen Bill, which could have converted all 20-year franchises to 50-year franchises. Such contracts would have cost Chicago over $150 million in lost revenue. It took the combined forces of Chicago mayor Carter Harrison and 1st Ward bosses Coughlin and Kenna along with lots of bribe money to defeat Yerkes's forces.

WABASH AVE., LOOKING NORTH FROM MONROE, CHICAGO.

THE CHICAGO WAY. To get things done in Chicago, one had to "boogle," or bribe, those in power to stay ahead of the game. Putting in the fix started with the local police. A famous Chicago card game was created to honor deception and trickery. It was called Bunco, and each card had a picture of a policeman on its back. The winning of elections in Chicago was easy since it was a one-party city. To get the vote out, voters could be bribed with whisky and money. Street bums were easily encouraged to vote, and out-of-towners were brought in to vote as well. Names found on tombstones were even used. Ballot slips were stolen and used over and over to add to the count. Police turned a blind eye to voter fraud.

557. Police Department on Parade.

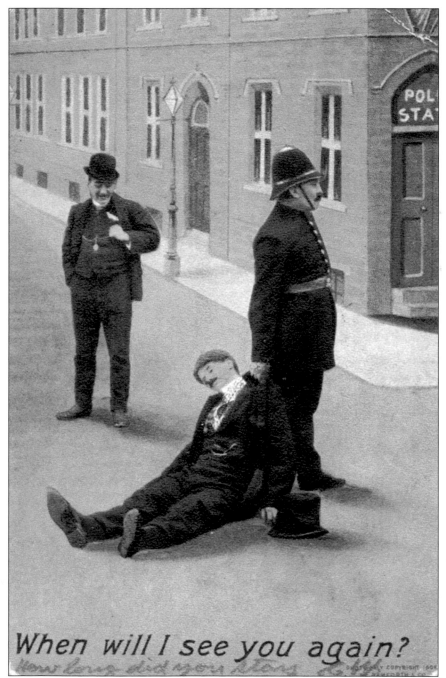

When will I see you again?

BACK TO JAIL. Once elections were over, it was party time in Chicago. On the streets, youths exploded zinc torpedoes under streetcars, and prostitutes went off duty to join the celebration. It was not uncommon for a few revelers to land in jail, and some of the more boisterous celebrations could also prove fatal. The 1928 city elections were called "Pineapple Primaries" because of exploding bombs and gang warfare in the precincts. That year, "Diamond Joe" Esposito, candidate for alderman of the 19th Ward, who was also involved in bootlegging, prostitution, and racketeering, was gunned down in front of his home during the partying.

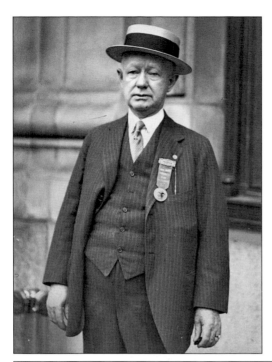

HINKY DINK. Chicago ward leaders dressed to the nines. When entering his tavern's opening near city hall, Hinky Dink Kenna, who ruled in the 1st Ward, was wearing a Prince Albert coat with a red flower and purple cravat with colorful pants. Kenna was short, hence the nickname given to him by *Chicago Tribune* publisher Joseph Medill. His hair was brushed into a pompadour, and he often wore a hat.

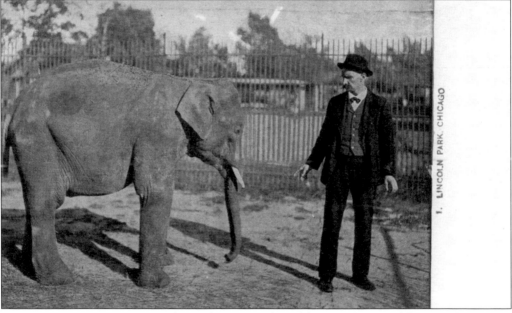

BATHHOUSE JOHN. Kenna's coruler of the 1st Ward, Bathhouse John Coughlin, used his money collected on the side to engage in financing his dream of owning his own zoo. Coughlin loved two things: whisky and animals. He bought an estate in Colorado Springs where he built his zoo and even took trainloads of friends to visit. His favorite animal was a small elephant, which he named "Princess Alice." She had been "borrowed" from the Lincoln Park Zoo, where the two are pictured in this postcard. Coughlin's zoo was immense and had a lagoon. In the evenings, Coughlin and wife strolled the lagoon pathway with Alice in tow. Both Coughlin and Alice were certified drunkards.

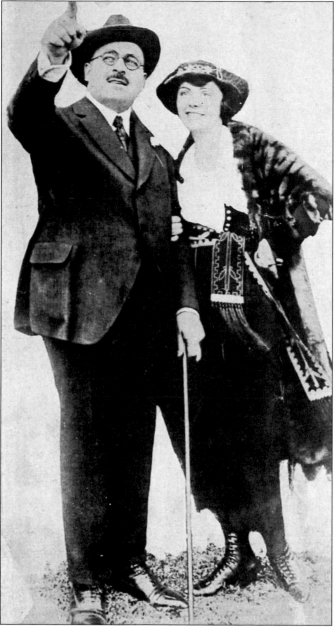

DIAMOND JIM. Vincenzio Colosimo—first nicknamed "Big Jim" and then "Diamond Jim" for his fancy white suits and impressive diamonds—was a petty criminal when 1st Ward aldermen Hinky Dink Kenna and Bathhouse John Coughlin elevated him to be their bagman. His power rose, and he soon controlled the criminal syndicate that would become the Chicago Outfit. He started with two brothels in 1902, luring girls to his Chicago café and farming them out as prostitutes. Eventually, he owned 200 brothels. He was gunned down in 1920, one week after marrying his second wife, Dale Winter, perhaps because he refused to embrace bootlegging with the onset of Prohibition; it is suspected that Big Jim's underling Al Capone may have been the trigger man. Winter, seen here on Colosimo's arm, had been a popular soprano who sang at Colosimo's restaurant. She later became a movie star in the 1940s.

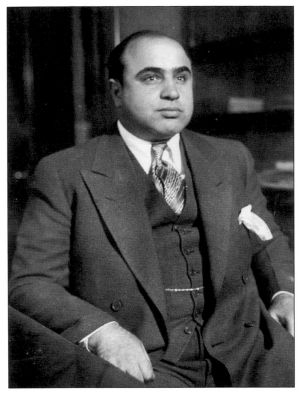

AL CAPONE. Gangsters in Chicago were big news, and so were their crime-fighting opponents. Chicago's most infamous mobster was Alphonse Capone, called "Snorky" by his friends. Capone started out as a bouncer in a South Side brothel owned by Big Jim Colosimo. There, he got syphilis and a scar on his face. His gang was known as the Chicago Outfit. Capone wanted to be liked and considered himself a good citizen of Chicago. He felt he was just a businessman, exercising his rights and serving the Italian community and the arts. In 1901, he started supporting the Chicago Boys Clubs and received a large silver loving cup in appreciation at a Sox Ball Club charity baseball game in 1931. Capone ran a soup kitchen in Chicago from 1914 to 1931. Starting in 1920, he made sure that all Chicago schoolchildren got free daily milk. (Left, Federal Bureau of Investigation; below, US National Archives and Records Administration.)

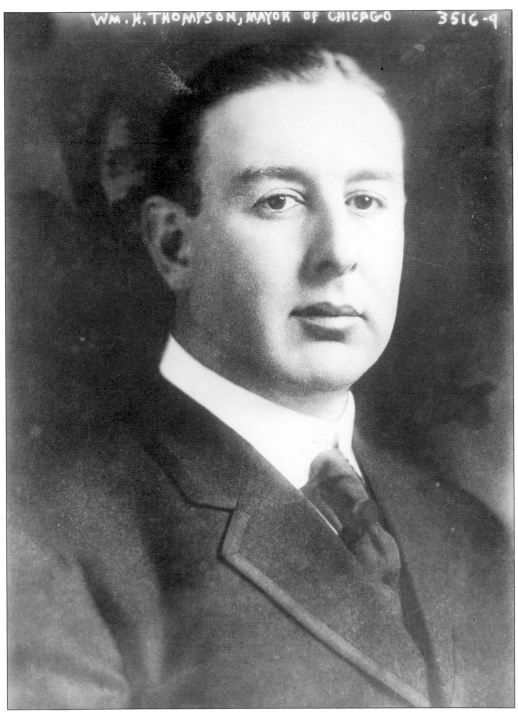

MAYOR THOMPSON. Capone made generous contributions, supposedly $250,000, to Mayor "Big Bill" Thompson to get reelected. Thompson was notoriously unethical. Indeed, during the years 1893–1934, Chicago saw a vast array of politicians, police, and criminals out to make Chicago work to their advantage. They were all part of a dynamic system that thrived on greed and self-preservation to rob the public. (LOC.)

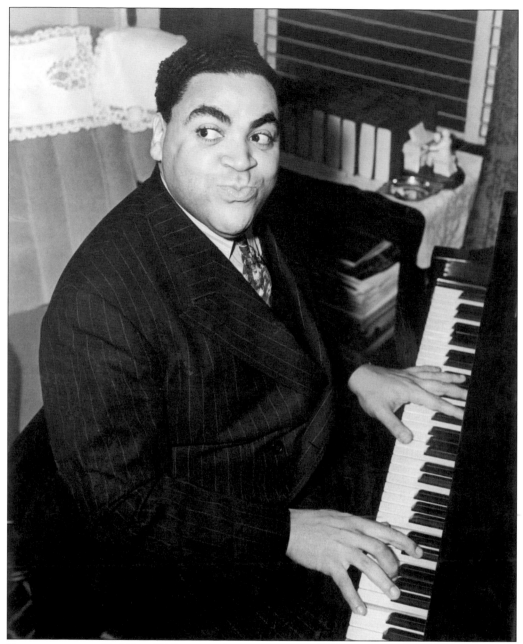

THANKS FOR THE TIP! Fats Waller, seen here on piano in 1930, was a very popular ragtime and jazz musician in Chicago. He helped introduce the boogie-woogie dance to white audiences. In 1926, he had an experience that he would never forget. Thugs kidnapped Waller at gunpoint after his performance at a Chicago nightclub and carried him to the Hawthorne Inn, owned by Al Capone. When he entered, a party celebrating Capone's birthday was in progress. At this point, Waller realized that he was not going to die, but play. And play he did—all night and into the morning. Waller left three days later, drunk and with thousands of dollars stuffed into his pants pockets—tip money from Capone!

Three

GAUDY OPERA

"OUR MARY" GARDEN.
Lollapalooza days played out
not only at boisterous political
parties directed by the Chicago
City Council on the South Side,
but also at points farther north
in town. Opera companies in
Chicago came and went during
these years, suppling plenty of
questionable performances on
stage and in public. Chicago
Grand Opera reigned from 1910 to
1914, Chicago Opera Association
from 1915 to 1922, and then
Chicago Civic Opera from 1923
to 1932. The biggest star of that
entire era, seen here enjoying a
tennis match, was Mary Garden.
Chicago dubbed Mary Garden
"our Mary." She eventually took
over Chicago Opera Association
and served as its "directress."
Under her rule, money was spent
in a lavish fashion. Garden had
Harold McCormick of Chicago
in her pocket as a benefactor.
Under their rule, the company
ended up $1 million in debt.

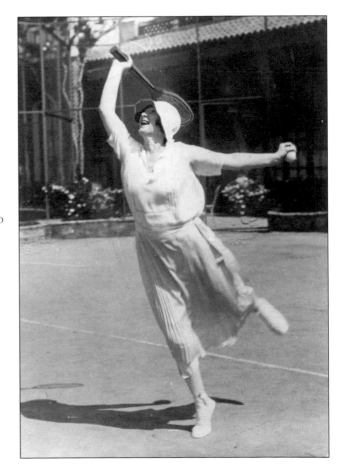

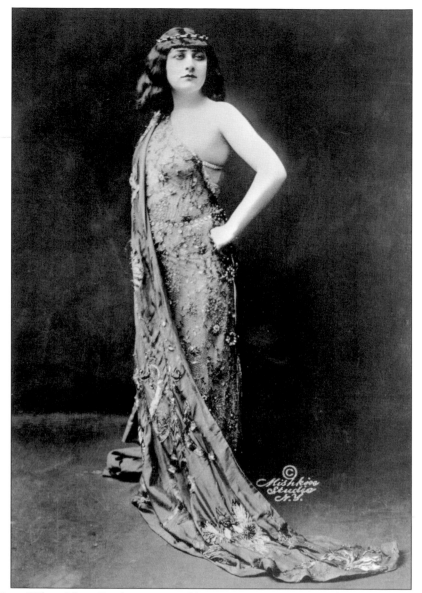

RISQUÉ ACT. When Mary Garden came to Chicago to sing, opera news became front-page news. In those days, the devil may have been embodied in the South Side red-light district, but his tail swished all the way north to the opera house in the Auditorium Theatre, triggered by Garden. Her portrayal of a teenage nymphomaniac named Salome, seen here, was the central character in an opera by Richard Strauss that shocked many Chicagoans. Her costumes and the "Dance of the Seven Veils" were deemed very scandalous, and her performance concluded with a kiss on the lips of John the Baptist's severed head! Police chief Roy T. Steward attended the first night's performance in November 1910 and did not like what he saw. He said, "Miss Garden wallowed around like a cat in a bed of catnip. If the show was produced on Halstead Street [they] would call it cheap, but over at the Auditorium Theatre they call it Art." Steward missed his calling. He would have been a first-class Chicago newspaper critic! The next two performances of the opera were quickly sold out. Quite the celebrity, Mary Garden had a dress and cosmetic line and even endorsed cigarettes even though she did not smoke.

PEEK-A-BOO WARDROBE. Was lots of flesh actually shown on stage? No, but clever costuming made it seem so. Garden's gown for Salome, copies of which were later sold in quantity in Garden's dress line, had straps on one side cut low with a transparent flesh-colored cloth covering the breast. On a darkened stage, the dress gave the illusion of nudity. The fourth performance was canceled. Such goings-on filled opera seats in the long run. Husbands, not usually found in an opera house, grabbed their binoculars and wives and headed for a night out.

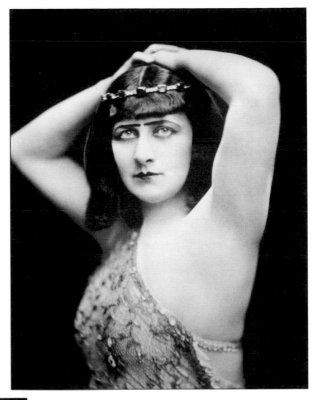

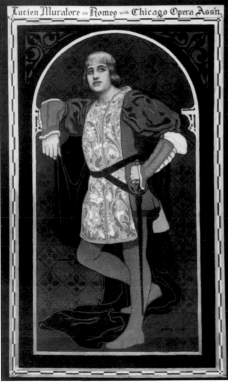

LUCIEN MURATORE. Beautiful female singers on stage attracted men to the opera, and beautiful male singers played to the women in the audience. Tenor Lucien Muratore was one such piece of eye candy. Dark eyed and trim in his portrayal of Samson in the opera *Samson and Delilah*, he showed plenty of flesh for female operagoers to drool over. Muratore sang often with Garden. Garden feared that his popularity would overshadow her own image as Chicago's greatest opera star.

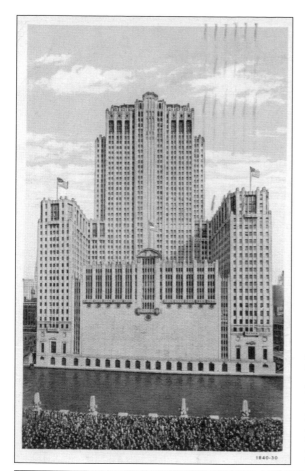

A New Home. Chicago's illustrious Samuel Insull finally took command of things at the opera, slashing personnel, salaries, and expenses. Singers under contract, such as Rosa Raisa, were forced to buy stock, which in the end proved worthless. Insull, a financial wizard, saw that the Auditorium Theatre space (below) was too large to fill. He built a more modest opera house on the Chicago River west of the lakefront. The rear of the new Civic Opera House from the river (left) looked like Insull's throne. The building was designed to rent out offices on its upper floors to provide income to support opera in hard times. The Great Depression was too much for this plan to be a success.

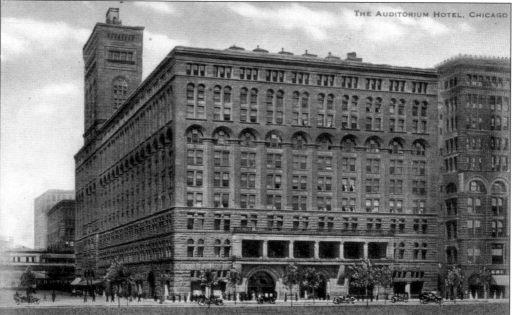

THE AUDITORIUM HOTEL, CHICAGO

HUSBAND FOR SALE. Opera stars' personal lives, like those of movie stars, filled newspapers and magazines in the 1920s. In 1927, the headline "Wife Sells Husband to another Woman" appeared. The seller was Chicago Civic Opera's mezzo-soprano Irene Pavloska. According to court records, she had sold her husband, Dr. Maurice Mesirow, to a woman recorded as a "Jane Doe." The story was so hot that the *Chicago Tribune* ran 38 pieces on the drama in 1928.

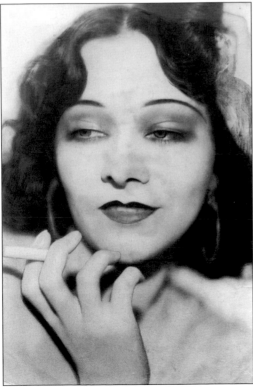

COE GLADE. Another great femme fatale in the 1920s was Coe Glade. Her roles as Carmen and other feisty females in charge of their lovers were most memorable. Glade sang and danced the role of Carmen 2,000 times before her retirement in 1963. She sang in Chicago opera performances from 1928 to 1932.

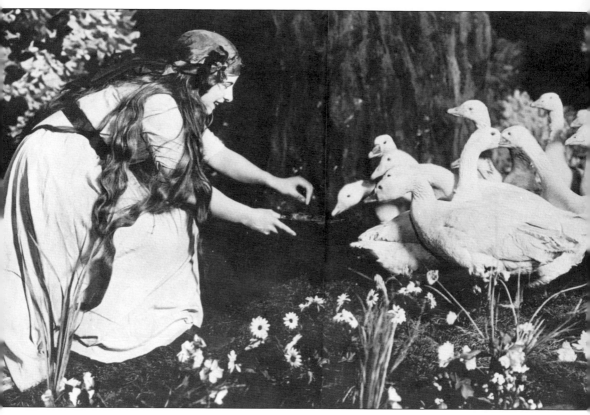

THE GOOSE GIRL. Usually, opera singers only worried about being upstaged by another singer, but Geraldine Farrar had to manage a gaggle of mean geese in Humperdink's opera *Königskinder* at the Auditorium Theatre.

THE INDIAN. Opera stars went to all lengths to attract attention. Cyrena van Gordon, another Civic Opera star, endorsed a line of corsets and was made an honorary Indian with her own war bonnet. Indians had long been negatively regarded as savages, but by the turn of the 20th century, in literature, art, and music, Native American culture began to be seen as worthy of preservation.

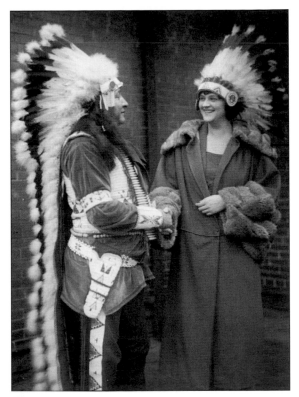

THE FLOP. Victor Herbert, a composer of classical music, decided to write a musical about West Coast Indians. *Natoma* premiered and was taken on tour in March 1910. Despite its lead roles given to Chicago's best singers—Mary Garden and John McCormack—critics called *Natoma* the biggest flop in opera history.

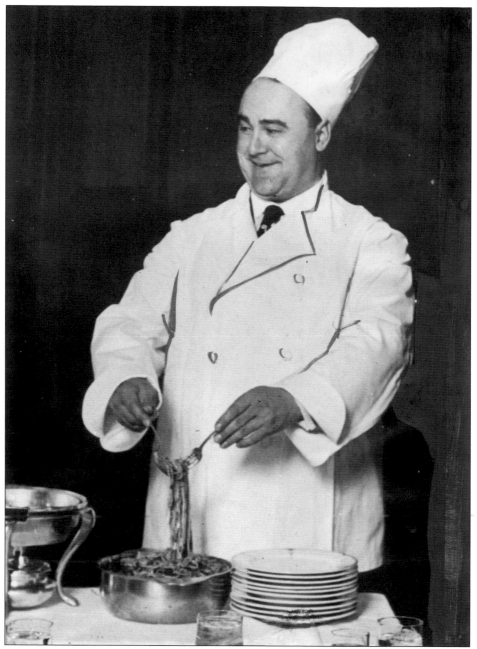

THE CHEF. The greatest male singer in the 1920s Chicago Civic Opera roster was tenor Charles Marshall, who was virtually the house tenor singing with all the major female leads, such as Garden and Edith Mason. Marshall also sang in Europe under another name. He recorded over 20 RCA records but refused to let them be released. The master discs were returned to him, and later, he turned them over to an institution in Chicago—their whereabouts are still unknown! However, there is a record of Marshall's 1926 recipe for spaghetti ingredients. Marshall loved to eat and cook. He searched Chicago's Italian grocery stores for spices to use in his spaghetti. Dried mushrooms and bay leaves were key ingredients specifically mentioned in a newspaper story along with a picture showing him as "Chef Marshall."

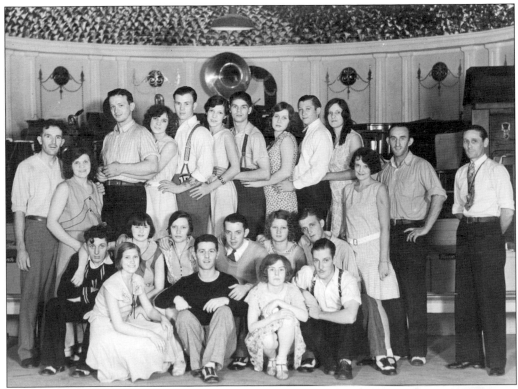

RISING STARS. Entertainers loved to stress how much they had to suffer in their rise to stardom. Opera singers were no exception. In 1926, Florence Misgen of Minnesota wrote to Chicago Civic Opera general manager Edward Johnson, asking for an audition. She did not hear back and decided to pop in on him in Chicago. She arrived in his office on a day when he had a full slate of auditions under way. She was added at the end of the morning auditions. Johnson heard her sing and said, "You have intelligence and a voice. We can ask for nothing more. Come back this afternoon and you may sign a contract." Her story appeared back home in the St. Paul newspapers and the local press. Success took only one day for her!

ROSINA GALLI. An early eye-pleasing ballerina who danced the lead roles for the Chicago Opera Association was Rosina Galli. She left Italy with her mother and settled in Chicago in 1911. She is said to have had powerful pirouettes. Her most spectacular role was in Rimsky Korsakov's *Golden Cockerel*.

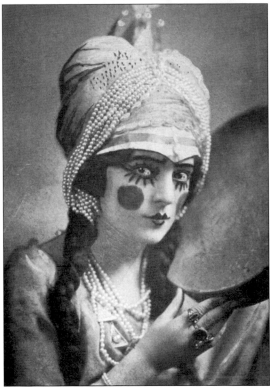

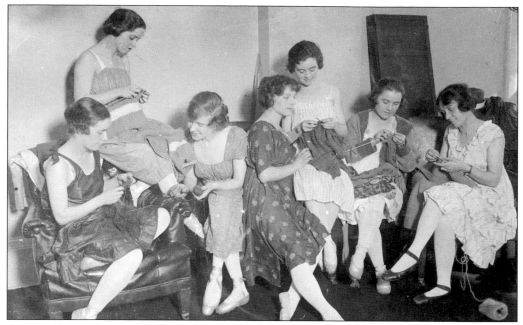

ON THE ROAD. For an opera company of that day to be successful, it needed to operate all year long if possible. During Mary Garden's years, Chicago Opera presented a fall-winter season in Chicago and then traveled by rail to the East, South, and West. In the summer, they were the resident opera company at Ravinia Park in Highland Park north of the city. When on tour, they needed a separate train to carry their sets, costumes, riggings, and roustabouts. The staff, singers, and ballet members traveled on a separate train. Sometimes, the company performed in tents rather than halls. Above, Chicago Opera Company girls are seen knitting while on tour in New York City. Below, the Chicago opera stars pose for a 1921 group photograph in Tucson, Arizona. (Above, LOC.)

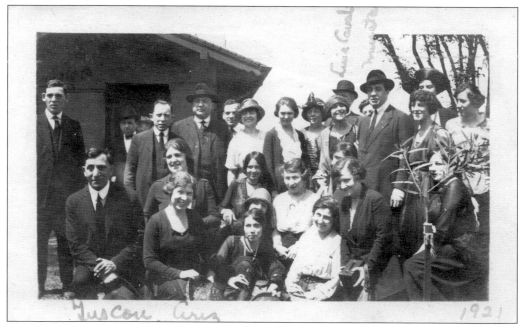

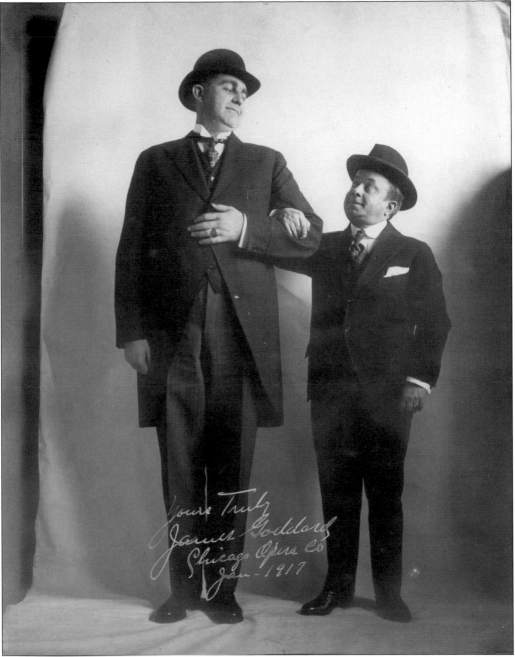

SHORT AND TALL. The 1917 tour included baritone James Goddard, who was six feet, seven inches tall. A picture of him with a nearby circus midget is hard to resist. The Garden-headed Western tour took trains on the Chicago, Milwaukee, St. Paul & Pacific Railroad to Wichita, Tulsa, Memphis, Chattanooga, Los Angeles, Fresno, Oakland, Portland, and Seattle.

Operatic Beauty. All opera singers needed a fine photographer to capture their appeal to sell the public, booking agents, and musical magazines on their star quality. In Chicago, there were several good photographers available. Jean Rudolf Matzene was a photographer for the *Chicago Tribune* in 1907 and for the opera companies starting in 1910. Also in town were Maurice Seymour and Charles C. Pike. In 1921, Pike photographed the fabulous Amelita Galli-Curci, the only opera star to headline in Chicago and at the Metropolitan Opera in New York City.

ANOTHER DUD. The famed Italian composer Pietro Mascagni did not always write successful operas, and one of his real duds was associated with Chicago. It looked good on paper, featuring a Lady Godiva lead—a nude woman on horseback. This theme would work at the 1933 World's Fair, when Sally Rand pulled it off, but not in Mascagni's opera *Ysobel*. Bessie Abbott, pictured here, was to play the nude figure on horseback. In 1908, as a member of the Chicago Opera Company, she had been the lead in *Mignon*. She had also formed her own company and toured in 1910–1911. Abbott's greatest experience was singing with Enrico Caruso in San Francisco the night before the Great Earthquake in 1906. *Ysobel* was finally produced at the Lexington Theatre in New York City in 1918.

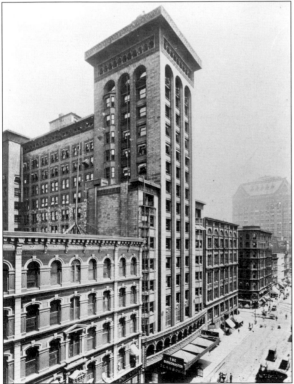

SCHILLER THEATER BUILDING. The lavish Schiller Theater Building, constructed for the German Opera Company, was one of the city's tallest buildings when opened in 1891 at 64 West Randolph Street. The Schiller featured a beautiful 1,300-seat theater, designed by famous architects Louis Sullivan and Dankmar Adler. It would later be named Dearborn Theater and, finally, Garrick Theater. It became a Balaban and Katz movie house in the 1930s and was razed in 1961, despite a highly publicized preservation campaign, to make way for a parking garage. (LOC.)

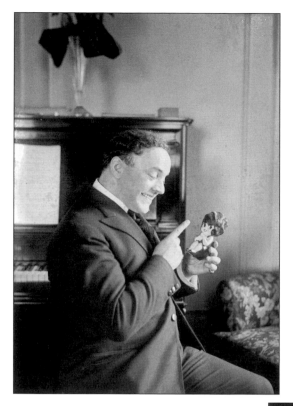

CHARLES FONTAINE. Charles Fontaine, pictured with a doll at the Civic Opera House, debuted with Chicago Opera in January 1919 while touring at the Lexington Theatre in New York City with Mary Garden and conductor Cleofonte Campanini. At Chicago Opera, he shared tenor roles with Lucien Muratore.

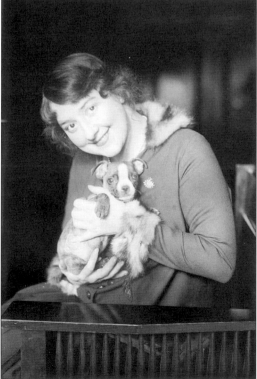

ANNA FITZIU. From 1916 to 1919, Fitziu was the principal soprano of the Chicago Opera Company. In 1919, she sang the lead in the US premier of Alfredo Catalani's opera *Loreley*. She is seen here with her dog in 1916.

Four

MOVIES AND SETTLEMENTS

THE BIG SCREEN. Evil ways seem to be all that Chicago was about, but there was more to the city between 1894 and 1933. Chicago had its good side too. North of the Loop, silent film companies were making movies at such a rapid rate that the city could lay claim to being the country's first film capital.

BEFORE HOLLYWOOD. The leading film studio was Essanay Studios at 1334 West Argyle Street. This studio was founded by George Spoor and Bill Anderson, and they chose an Indian face for their logo. Many of Essanay Studios' films were shot nearby in Rogers Park. The studio name sounds French but was a play on the founders' first initials of their last names: "S and A."

BRONCHO BILLY. Anderson became the studio's first cowboy actor and was called "Broncho," thus becoming the first named cowboy actor in films. He is seen here in full cowboy regalia for a 1913 issue of *Broncho Billy* magazine.

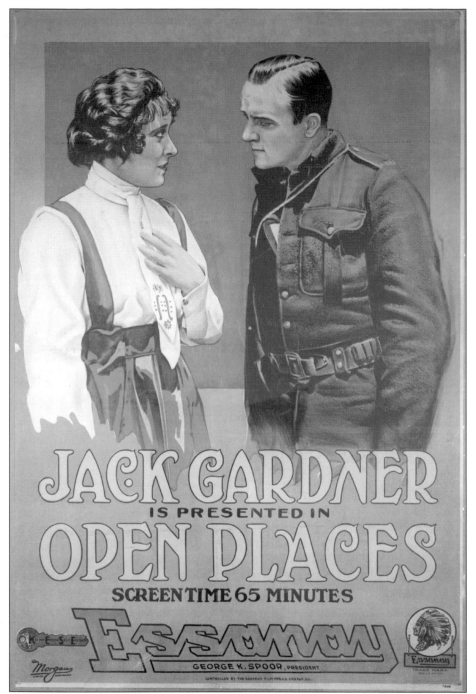

ESSANAY PROMO. Essanay's George Spoor was no actor, but rather an inventor of movie-making devices. He invented a process whereby multiple copies of films could be made inexpensively for distribution to movie houses all over the country. Spoor was way ahead of his time when he came up with a projector that not only showed films in 3-D but also used 65-millimeter film, making it possible to show a wide-image movie on screen. Many famous Hollywood actors started their careers with Essanay and other studios in Chicago. This ad was for the 1917 Western *Open Places*. (LOC.)

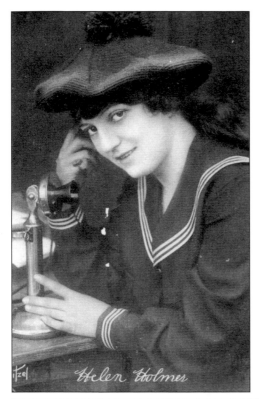

Helen Holmes

HELEN HOLMES. One of the most famous screen actress serial makers was Helen Holmes, who was born in the 15th Ward in June 1892. She attended St. Mary's Convent and modeled for Santa Fe Railroad posters early in her career. She spent some of her time in Death Valley, panning for gold and living with Indians. Holmes was not a typical woman either on or off stage. She liked typically male things and performed her own stunts in films, and also liked to drive fast cars and locomotives. In *The Hazards of Helen* films, she fearlessly drove a car off the San Pedro pier onto a barge 30 feet away in the water. On the fourth attempt, she made it. Holmes was an excellent example of a late-Victorian woman breaking out of her mother's footsteps in Chicago.

RAILROAD RAIDERS. Pictured is J.P. McGowan (right) on set for the 1917 silent film *Railroad Raiders*, produced by Chicago's Signal Film Productions. Helen Holmes played opposite McGowan as the young heroine, and the two would star in many movies together and end up getting married.

GLORIA SWANSON. Two of Hollywood's biggest stars, Gloria Swanson and Charlie Chaplin, had ties to Chicago. Both worked for Essanay. Swanson was born in Chicago in 1897 and knew from an early age that she wanted to be an actress. She and her family lived at 341 Grace Street, just east of Clark Street. She took singing lessons and attended the Art Institute of Chicago. Swanson's aunt took her in 1912 to Essanay Studios for an audition, and she was hired as an extra for four days. This job earned her $3.25 for the week. She is pictured here with her third of six husbands, Henry de La Falaise.

CHARLIE CHAPLIN. Chaplin was a well-established comic for Keystone Films when he jumped ship and went to Essanay. Essanay was getting bigger and gambled on Chaplin's fame to further boost its fame. He was promised a salary of $1,250 a week, unheard of at the time. Unfortunately, Chicago did not make Chaplin happy. For a time, he lived with Spoor, and later in a small apartment on the South Side, staying mere months in town making movies. He is seen here in 1915, the year he signed with Essanay, where he wrote, directed, and started in 15 films. (LOC.)

MUSIC IN THE AIR. Swanson and Chaplin shared one characteristic that presented a problem: they were both short people. Cameras sometimes compensated for that, and casting also compensated by only hiring short people for their films. Chaplin and Swanson went to Hollywood, and Swanson, unlike Chaplin, survived to appear in talking pictures in the late 1920s. She was quite a dresser, wearing stylish, bold clothes. A good makeup artist was able to give her many different looks. She liked to drive around on the North Side of Chicago in her expensive convertible and be seen. She was called Chicago's "Uptown Sweetheart." She added singing to her act when she appeared in the 1934 movie *Music in the Air*, from which this still was taken on set. It was a musical about Gustav Mahler. Swanson married Wallace Beery, another Essanay actor, before she went to Hollywood. They appeared in two films together in 1915 and 1916. Beevy went to Hollywood as a leading man and character actor.

SOCIAL REFORM. Many immigrants were so poor that they needed help in order to survive in Chicago. Family members, churches, benefactors, and public institutions were established for their needs. Jane Addams and Ellen Gates started Hull House settlement in 1889 to aid families with learning English, finding a job or apartment, and developing new social skills. This portrait of Addams dates to 1906. (LOC.)

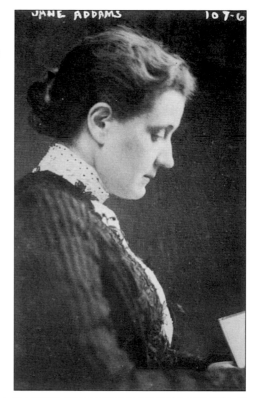

ABRAHAM LINCOLN CENTER. Wealthy community benefactors also established relief centers. Ida B. Wells-Barnett moved to Chicago in 1894 and became famous for her role as a writer-publisher and crusader against black lynching in the South. She and her husband, Ferdinand L. Barnett, were well-to-do and lived in a mansion. At a time when few other settlement houses accepted blacks, she started a settlement house in Chicago for blacks emigrating from the South. Built in 1913, the Abraham Lincoln Center was a settlement house for the black community at Oakwood Boulevard and Langley Avenue, across from the All Soul's Church in Bronzeville.

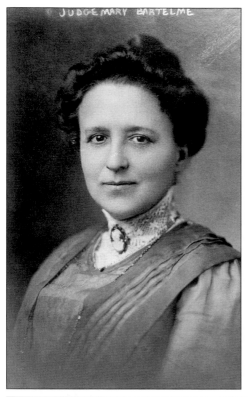

JUDGE MARY BARTELME. Another suffragist, Judge Bartelme became the first woman judge of the Circuit Court of Cook County in Chicago and committed her life to children's welfare reform, specifically focused on helping young girls who had been trapped into a life of prostitution. She earned the nickname "Suitcase Mary" because she always gave these girls a suitcase full of clothes and provisions en route to the foster home. Between her three Mary Clubs in the city—shelters for girls with no home to go back to—an estimated 2,000 girls were rescued between 1914 and 1924. (LOC.)

ST. PETER'S CHURCH. At the corner of Polk and Clark Streets, St. Peter's was a South Side haven with its Franciscan friary directors to aid the city's Catholic immigrants. Other denominations also helped those new to the city. Typically, settlement houses and centers catered to the nationalities specific to their area or neighborhood; for example, those in Little Italy helped Italians. Beginning in 1900, the Medical Missionary College Settlement was established in Chicago. Other settlement centers were at Clybourn and Archer Avenues.

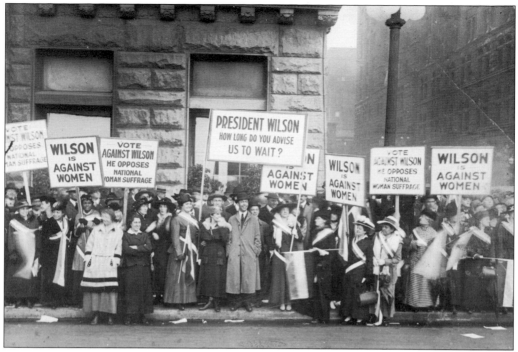

CHICAGO SUFFRAGISTS. Amidst all the crime and corruption during these Lollapalooza days, social reformers had built a movement of their own. Nowhere was this more evident than with the suffragists. Pictured above in 1916, suffragists are protesting against Pres. Woodrow Wilson because he opposed the right of women to vote. Below, they parade outside the Chicago Coliseum, site of the 1916 Republican National Convention. That party, in its official platform, did support the extension of women's suffrage but left it up to each individual state to settle the question, rather than as a national referendum. (Both, LOC.)

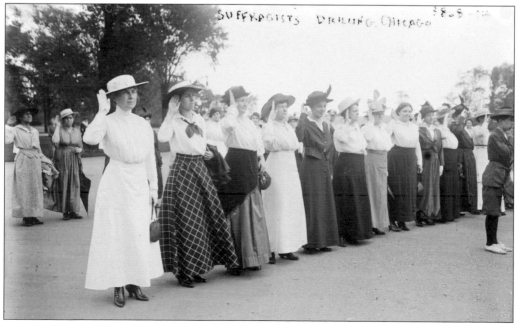

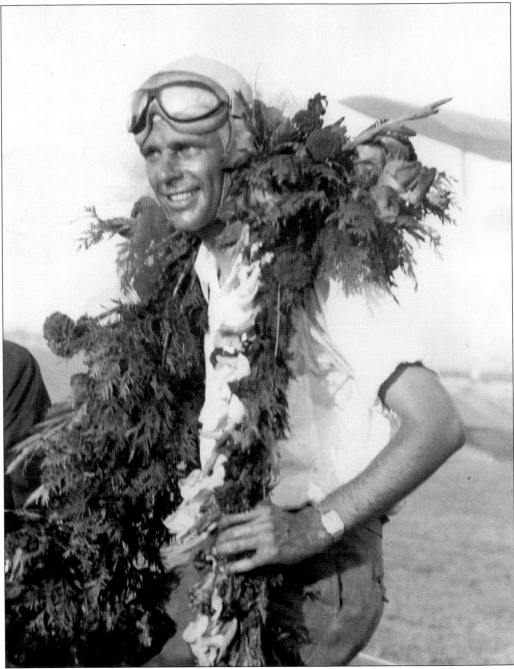

RAY MOORE. Chicago was one of the early centers of flight, and many air races were flown over the city to attract residents and visitors. Ray Moore, who flew passengers between Chicago and Dallas, Texas, between 1927 and 1930, would become a world-famous test pilot in the 1930s. He flew many races, sponsored by Frank Phillips of Phillips Petroleum, including Woolaroc competitions. The race name came from "woods, lakes, rocks." Moore also helped make a Hollywood film about test pilots.

ILLINOIS THEATRE. Located at 65 East Jackson Boulevard, the Illinois Theatre was built in 1900. It was designed by Benjamin Marshall, who also did the landmark Drake Hotel and the Blackstone Theatre and Hotel. A legitimate entertainment center at the turn of the 20th century, this theater, like others, turned to Ziegfeld Follies and other stage reviews by the 1910s. It began showing movies in the 1920s.

STATE-LAKE DANCER. The State-Lake Theatre in Chicago showed not only movies but presented live dancing girls on stage as well. The building also housed offices, and one of the offices was that of Bloom Studios, a photography firm that trained the famous Maurice Seymour in his craft of photographing beautiful show girls. The Bloom Studios could have girls performing downstairs at the theater pop in for photo shoots.

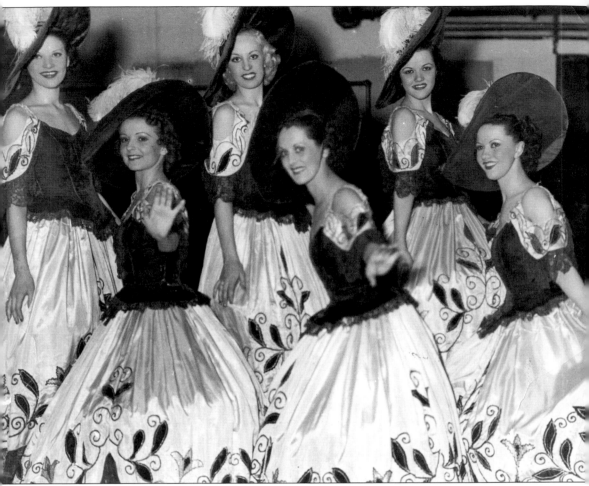

Dancing Sweethearts. Once the movies found their voice, they attracted more viewers, meaning theaters were filling more seats. Movie palaces sprang up in Chicago, and they were air-conditioned. Between movies, the theaters offered up short-subject films, news reels, cartoons, previews, and a live symphony orchestra with kick-line dancing girls. The State-Lake Theatre dance company was known as the Sweethearts. It was a tight-knit group of 12 girls who considered themselves a sorority. Their colors were blue and gold, and the leader was Ruth Fossner. Dancer Ronnie Haigh (front row, center) kept a scrapbook of their adventures. Pictures of the group appeared often in the Chicago newspaper—they boosted sales. One picture showed the Sweethearts dancing on 12 drums. Ronnie was photographed in the Chicago Boston Store cutting a 1,500-pound cake to honor a six-year-old collie, Snoozer, who appeared in Hollywood movies before Lassie.

Five

MUSIC AND DANCERS

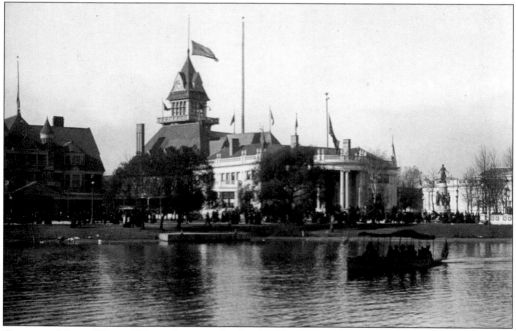

CENTRAL MUSIC HALL. When the city rebuilt after the 1870s fires, some of the largest and finest buildings that went up were churches and music halls, for these two institutions were central to the life of the city. In 1879, work was started on the six-story Central Music Hall at State and Randolph Streets, and the building was completed by the end of the year. Designed by Dankmar Adler, it featured a large theater, offices on the upper floors, and storefront spaces on the street level. A key design feature of the theater was that the main floor was slanted up from the stage, allowing those in the back seats to have a better view of the stage. Later, Adler helped design other great Chicago theaters, such as the Auditorium Theatre. The Central Music Hall was demolished in 1901 to make way for a new Marshall Field Building.

HEAR THEIR VICTOR RECORDS

THE BENSON ORCHESTRA
OF CHICAGO
ROY BARGY DIRECTOR

MAKING IT BIG. Chicago musicians and dancers of the era drew worldwide attention. Race, gender, and language took a backseat to the music and dance that filled the city. All that mattered was the beat-beat-beat of the music and the tap-tap-tap of toes. This was a time to strike up the bands and move the body in Chicago's concert halls, nightclubs, hotels, and speakeasies. Chicago, at this time, was best expressed in its music, a reflection of its diverse people. The Benson Orchestra of Chicago made it big in the 1920s. Based out of the popular Marigold Gardens, they began recording with Victor in 1921 and featured the legendary Gene Krupa on drums. Benson is pictured at the piano.

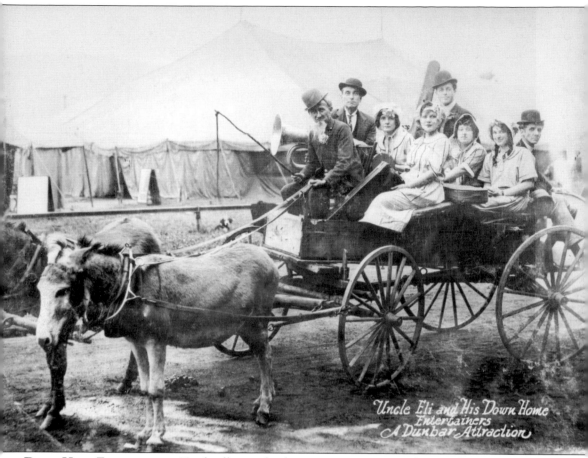

Uncle Eli and His Down Home
Entertainers
A Dunbar Attraction

DOWN-HOME ENTERTAINERS. Vaudeville was the dominant entertainment force in the 1890s. This collection of performance acts was everyone's cup of tea and was very family friendly. Magicians, opera and ballad singers, dancers, comedians, strong men, trained animals, jugglers, orators, and Shakespearian actors crossed the stage in rapid succession—sometimes 24 hours a day. These shows traveled all across the nation, playing in cities, towns, and villages. In 1895, Chicago's Opera House and Academy of Music were rented for vaudeville shows. Pictured here is Chicago entrepreneur Ralph Dunbar's hillbilly group, Uncle Eli and His Down Home Entertainers.

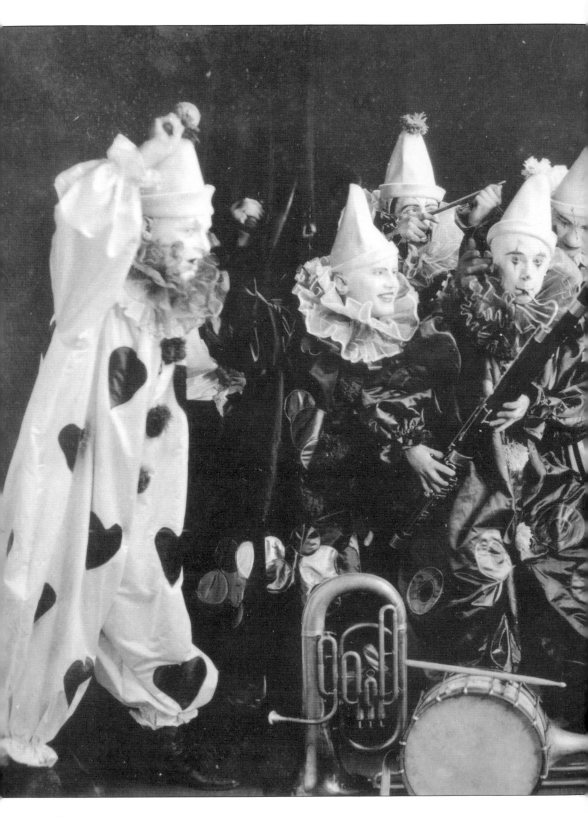

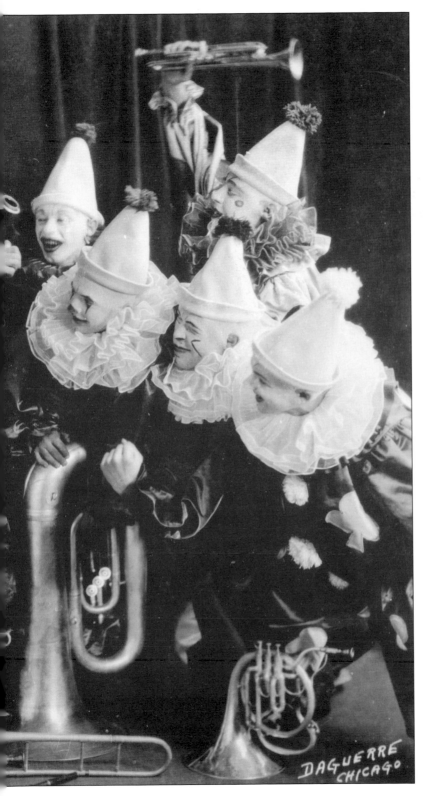

DAGUERRE
CHICAGO

CLOWN LAND. The great musical skills of Chicago's Ralph Dunbar reached into vaudeville and included such acts as Clown Land, which headlined shows across the country. He also provided acts for Chautauqua meetings and lyceums.

65

RALPH DUNBAR. Dunbar had schools of music that ran the gamut from opera to musical clowns. Dunbar groups toured the country in 1921–1922 with *Carmen, Robin Hood,* and *Bohemian Girl.* He even established the Dunbar American School of Opera in Chicago at 1537 East Fifty-Third Street in the city's Hyde Park neighborhood.

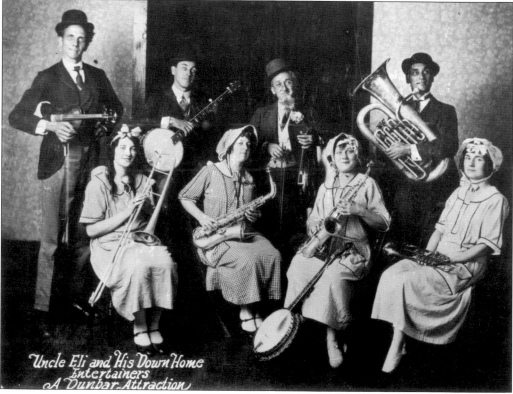

Uncle Eli and His Down Home Entertainers A Dunbar Attraction

DANCING COMEDIANS. George and Arline Colston were part of Chicago's vaudeville scene in the 1930s and 1940s, doing comedy skits while dancing, sometimes even on ice! George was skinny and wore lift shoes. Arline often wore short mink coats with lots of leg showing. The Colstons appeared in short films in the 1930s and even made it to early television, appearing on the Ed Sullivan Show.

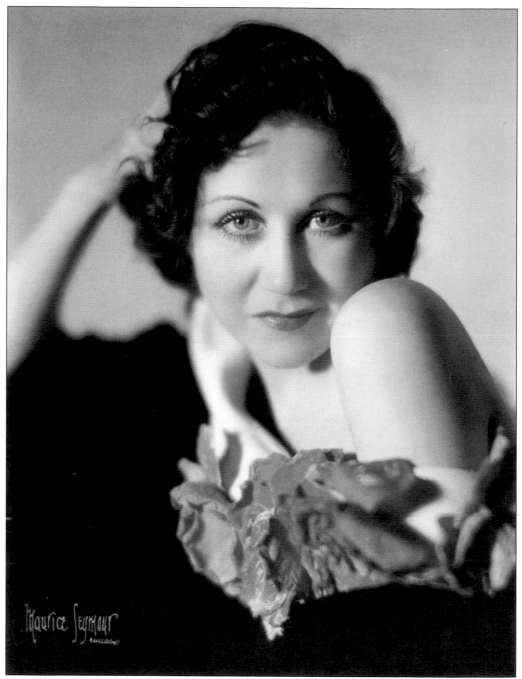

Helen Charleston. A popular way to raise money for charity in the lean 1930s was to sponsor a variety show. The Chicago Variety Show Benefits featured such out of town troupes as the Earl Carroll Varieties. Carroll was a former World War I pilot whose girlie shows earned him the title of "Troubadour of the Nude." His show at the Hippodrome in the 1930s featured more than just scantily clad girls, with a world-class female comedian, called a mimic in those days, named Helen Charleston. Chicago photographer Maurice Seymour was fascinated by her charm and photographed her frequently.

VAUDEVILLE HOMES. There were three vaudeville circuits, the Orpheum, American, and black. All three circuits passed through and played at the Majestic, Palace, and Olympic theaters. Vaudeville soon had to compete with Follies. These shows usually had a story line. Follies poked fun at current events to get laughs, and were known for having scantily clad female dancers. Follies played to packed houses.

Chicago · Vaudeville Theatre · Formerly the Iroquois Theatre

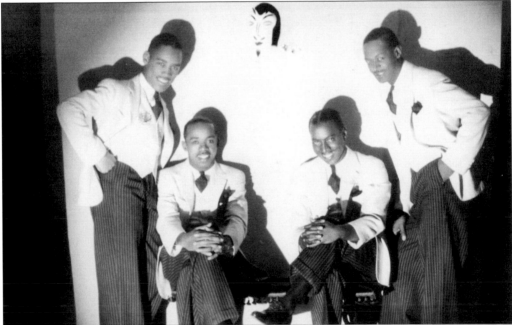

FOUR FLASH DEVILS. Black dancers introduced tap dancing; a true American-born art form, it evolved out of traditional black dancing and Irish dancing. Chicago was the perfect site and center stage for tap dancing, and by the 1920s and 1930s, white performers such as Fred Astaire and Shirley Temple become world famous. Tap became the dance of vaudeville, the Follies, and the movies as well. The Four Flash Devils, pictured here, were a popular tap dancing group that performed in Chicago and toured the nation in the 1930s. They appeared in a short-run musical flop in 1930 called *Change Your Luck*, but critics raved about their dancing. The Four Flash Devils were, from left to right, S.W. Warren, Billy Cole, Charles Gill, and C.P. Wade.

TWO FLOS. Dr. Florenz Ziegfeld, the head of a music school, had a son, Flo Jr., who visited a Paris fair and the Chicago 1893 World's Fair and convinced his father to try a toned-down version of Follies to help create interest in classical music studies. The Ziegfeld Follies, called the Trocadero Club, were a success. On stage were beautiful girls dancing to some classical piano and singing and a strong man, called Sandow, to interest the women in the club. A strong competitor of the Trocadero Club was the Silver Follies at 4000 North Wabash Avenue. Eventually, Follies filled the city, and the police conducted numerous raids. Flo Jr. took the idea and created the New York City Ziegfeld Follies, which dominated Broadway for years. Burlesque houses advertised on colorful matchbooks, such as the one below. Gone were the Victorian prudes offended by the uncovered legs of grand pianos and race horses. Women's legs attracted paying audiences, as proven by Chicago's two World Fairs.

MAJESTIC THEATER. Opened in 1906 at 18 West Monroe Street, the Majestic was a popular venue for early vaudeville. It offered over one dozen acts per day, six days a week. Being the first theater built in the city after the tragic Iroquois Theatre fire of December 30, 1930, where over 600 people died, it was renowned for its fire safety. Wisconsin resident Harry Houdini, the famous illusionist and escape artist, seen below handcuffed and bound in chains, was one of the theater's top headliners in the early 1920s. He helped charter the Chicago Society of American Magicians in 1917 and served as its president from that year through his death in 1926 (owing to a ruptured appendix resulting from a stomach-punching challenge). The society still operates today. The Majestic is now the 1,800-seat CIBC Theater and features Broadway shows. (Below, LOC.)

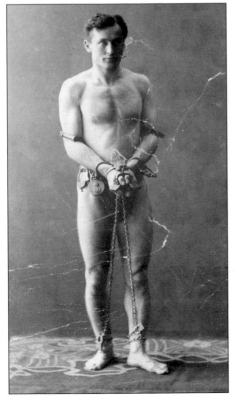

BLACKFACE. Minstrel shows started in the 1800s as all-black companies, featuring black folk songs and typically two sidemen—"Bones" and "Tambo"—who kept the scripted goings-on full of humorous stories and jokes. Banjos and other instruments livened up the show. Soon, seeing the popularity of the acts, whites began appearing in minstrel shows with blackface. Chicago's Williams Minstrel Review started out as an all-black cast with Egbert Williams and George Walker as the two sidemen. Later on, its cast became all white with only one sideman in blackface, and

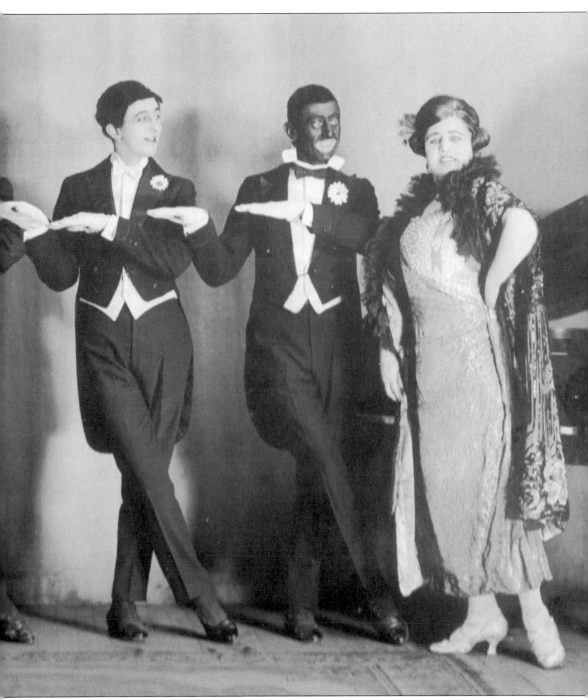

added singer Jean Leighton, as seen in this photograph. She and her troupe played at the Loew's Garden Theatre as a side act to movie features, and toured the country too. When minstrels became whites in blackface, the whole character of the shows changed. Now, they poked fun at blacks and their culture, and this colorful style of entertainment became poison fruit; its original celebration of black life was lost forever.

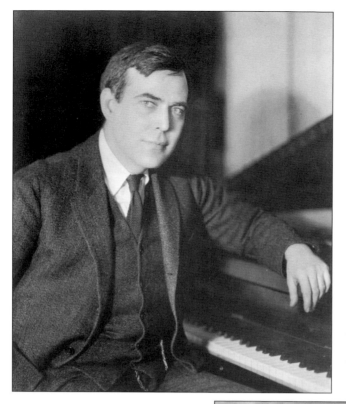

RACIST COMPOSER. John Powell was an important composer and pianist of the early 20th century. The Virginia native championed Southern Appalachian music. Born in 1882, he most likely visited the 1893 World's Fair in Chicago, which would account for him writing the piano suite in 1907 that included "Hoochee Coochee at the Fair," a tribute to hip-swaying Oriental dances. He also helped introduce music written by blacks to white audiences and wrote "Rhapsodie Negre" for piano and orchestra. However, Powell had a dark side; he was an outspoken racist. He founded Anglo-Saxon clubs and encouraged the state of Virginia to pass the Racial Purity Act of 1924, which labelled anyone with any percentage of black blood a "negro."

MAGICIANS ON STAGE. Fans of modern acts like Penn & Teller or David Blaine would have enjoyed the act of Largey and Morgner. This illusionist duo was a popular draw in Chicago and adorned the city's billboards in the 1930s. They are seen here as the "two-headed man."

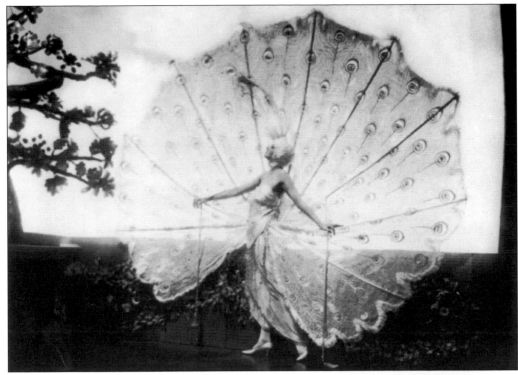

ZIEGFELD'S BEAUTIES. The Chicago Follies had its share of high-kicking beauties who made the headlines of local newspapers. The c. 1919 photograph above is of Delores Rose in a peacock costume. Pictured at right is Edna French, a member of the Follies in the 1920s; she mesmerized a young millionaire's son named Frank Gregg, and they married while he was still in school. Feeling French was just a gold digger, Gregg's parents wanted the marriage annulled. They were wrong; her family was very wealthy as well. Enter Gregg's Ivy League friend Bill Olcott, who fell in love with French, too—the battle was on! When the Follies returned to Chicago in 1922, Olcott came to town with his mother and convinced French to divorce Gregg and marry him.

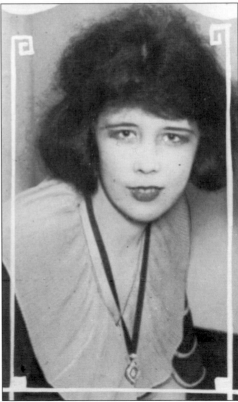

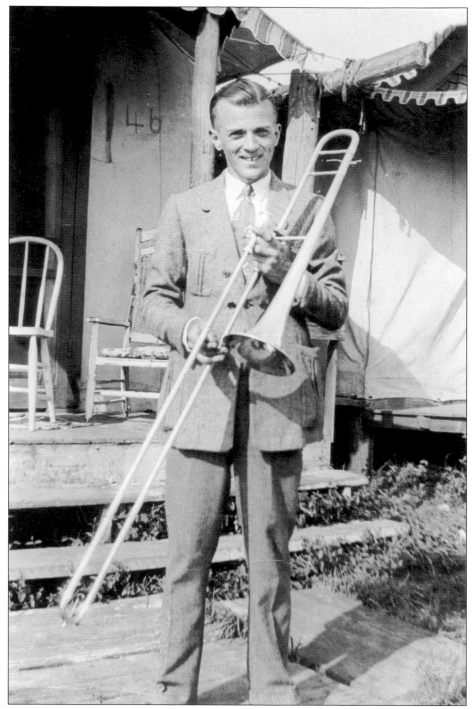

Homer Rodeheaver. Homer Rodeheaver was a trombonist and saxophonist. He also was music director for evangelist Billy Sundays's rallies. Rodeheaver wrote religious music and had his own record label, Rainbow Records, and recorded for Columbia and RCA records. He was a fine baritone singer and a friend of John D. Rockefeller. He and the oil magnate kneeled on a golf course one day and sang the song "I'll Go Where You Want Me to Go, Dear Lord."

PEKIN INN. One of the most exciting shows to catch in these days was held in the Pekin Inn at Twenty-Seventh and State Streets. The inn was a temple of black music, which attracted music lovers of all races to its evening frolics. It was owned by Robert T. Mott, who in 1904 had turned his saloon into an entertainment center and restaurant. Mott's friend and partner was Chicago's own Jack Johnson, world-famous boxer. The music director at the Pekin Inn was Joe Jordan. Jordan programmed all kinds of music in his shows, ranging from rags to operas. Jordan and the inn introduced many blues and ragtime standards and had their own in-house rag. Jordan recorded on Vocalion, Chess, and Okeh Records. Talented black pianists who got their start playing in the brothels of the Levee found themselves elevated to stardom when they played at the inn. Dreamland, Plantation, Elite, and Sunset were rivals of the Pekin Inn. (Right, LOC.)

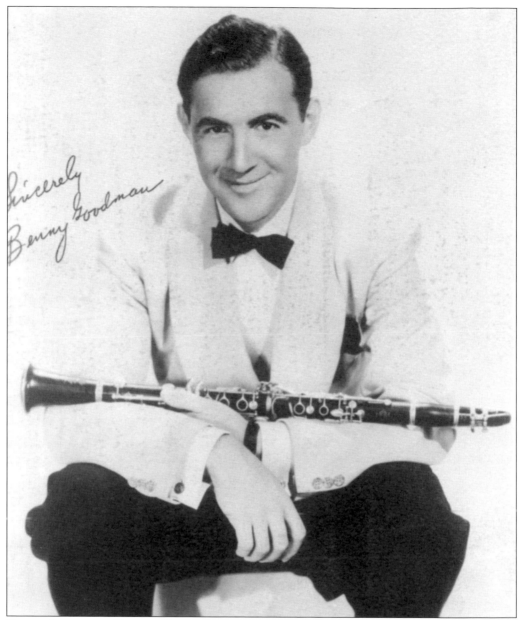

BENNY GOODMAN. Chicago's Dreamland Café was more than a small venue. It could seat 600 people and boosted 18 fans and 125 lights. In 1926, the café featured the Lil Hardin Band with Louis Armstrong on horn. All along State Street, there were music joints cranking out new swinging music. These places attracted young white music students who wished to put swing in their music. Clarinetist Benny Goodman from Harrison High School hung out on State Street, as did trumpeter Jimmy McPharland from Austin High School in the 1920s.

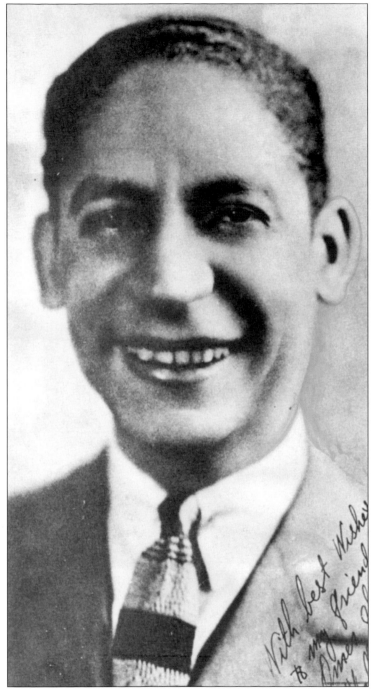

JELLY ROLL. Chicago's most famous early jazz band was King Oliver and His Creole Jazz Band, but later on, "Jelly Roll" Morton ruled in Chicago. Morton got his start in New Orleans. He played in bordellos but also went to the New Orleans Opera and transposed tuneful opera arias into songs played in the houses. His smile was set off by a diamond tooth. Morton opened his Deluxe Café on State Street in 1914. He claimed to have invented jazz. The records he cut while in Chicago are considered by some to be the best of his recordings.

SOPHIE, SINGING CARD SHARK. Sophie Tucker, who started life as Sophie Tuck, was of Ukrainian descent. She started her career in vaudeville, singing bluesy songs while in blackface. She pulled up her sleeve one night to prove to the audience that she was white but could still sing the blues. She was accepted by the audience and dropped the blackface. Tucker loved to sing at the Chez Paree and Oriental Theatre in Chicago. When she hit town, she spent her late evenings playing cards will Al Capone. When out of town, she played cards with J. Edgar Hoover.

SEXY SAXOPHONE. A revolution in music was brewing in Chicago at the turn of the 20th century. Young people were still taking up the violin and piano and other classical instruments, but a new bad boy with a sidekick came to town. It was the saxophone, whose throaty voice seemed to be the very sound of sex. The modern saxophones came in various sizes and were not all that expensive. C.G. Conn Company made them by the tens of thousands. They were sold not only to young men, but also young women, who were out to prove that they too could speak this new sexy musical language.

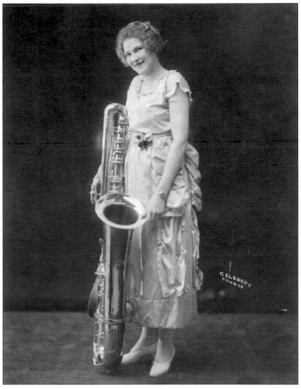

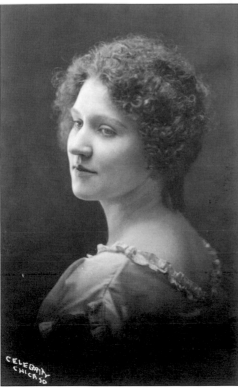

EVA DARLING. All-female saxophone bands were soon formed, and Chicago had the Darling Saxophone Four. Seen here is their manager, Eva Darling.

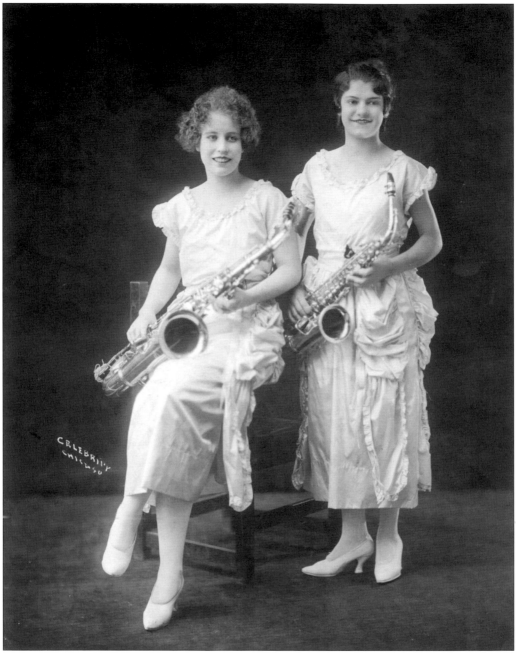

DARLING SAXOPHONE FOUR. Starting in 1910, the quartet performed on Conn saxophones. They also played under the name of the Four Harmony Maids in the 1920s. The quartet even played with the famous Arthur Pryor Band. Two of the members are pictured here.

INA RAY HUTTON. Next up in the 1930s were all-woman orchestras directed by a female conductor. Ina Ray Hutton and her orchestra played to packed houses as she swished and swayed with a baton in close-fitting gowns. Born Odessa Cowan in Chicago, she attended Hyde Park High School. The 1930 US Census classifies her as "mulatto." Her fans did not know of her mixed-race background.

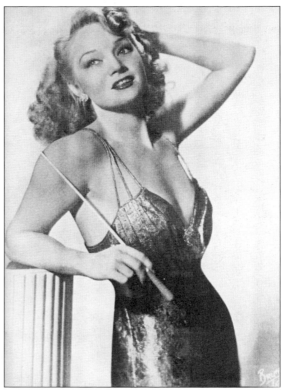

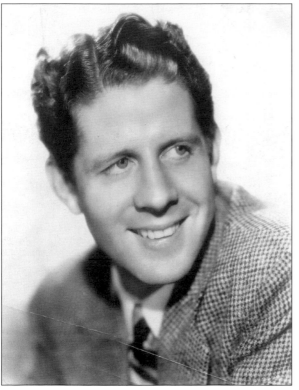

RUDY VALLEE. Chicago was a hot spot for male saxophone players who could also sing in a flat, weak-warble voice. Fleischmann's Yeast put Rudy Wiedoft, a saxophonist, clarinetist, and singer, on the radio in 1929. He was an instant success. Repackaged as Rudy Vallee, he went on to Hollywood stardom.

Tonk Manufacturing Co. Max Tonk, President.

Piano Stools, Piano Scarfs.

OFFICE AND FACTORY
CORNER CLYBOURN AVE. AND LEWIS ST.

Chicago, Dec. 17, 1906. 190___

TELEPHONE NORTH 33.

The M. J. Carnahan Co.,

Loogootee, Ind.

Gentlemen:-

As we were saying in our recent and remote communications:
Max Tonk's stools, benches, chairs, scarfs, covers, etc., are strictly
first class goods in every respect. No taint of "guess work" surrounds
this proposition. Time, temper and money are lost by a dealer or mer-
chant in buying and handling other than best equipment to accompany the
pianos and organs he sells.

Rest assured you will not lose one of these essential
ingredients to success in ordering and having Max Tonk's goods around
you. It goes without saying that our goods will materially increase
your sales. They are manufactured on honor and built to last a life
time. Thousands of established and reliable dealers know the connection
between Tonk's piano stools, benches, etc., and satisfactory popularity
and profit. They also recognize the Tonk goods as standard of ex-
cellence and will accept and use them as a basis of comparison when
occasion arises.

In addition to standard goods at the right prices we
offer you our staunch friendship as against catalogue mail order
houses.

Have our catalogue on your desk and mail your orders to

Your friends,

CHC

TONK MANUFACTURING CO.

HONKY-TONK. While open-minded music critics took to the new music forms, others panned it.
Etude magazine virtually branded jazz as a corruptor of youth. Black music was too sexy, encouraging
dancers to move their bodies in unnatural ways. Jazz and blues were denounced from pulpits all
over the nation. Street-front saloons that played such music were called honky-tonks. A strange
word, since it comes from the combination of the expression "honky," which was used by blacks
to refer to whites, and "tonk," a piano/stool maker in Chicago of Ukrainian descent. Tonk piano
benches were mass produced and found in most Chicago homes.

VERNE BUCK. One of the most popular movie stage orchestras in town was directed by Verne Buck. He planned out elaborate vaudeville-like shows. Buck started out in 1928 directing shows in the 3,250-seat Balaban and Katz's Chicago Theatre. Later, he moved across the street to head up operations at the chain's State-Lake Theatre. Today, the theater is home to Channel 7.

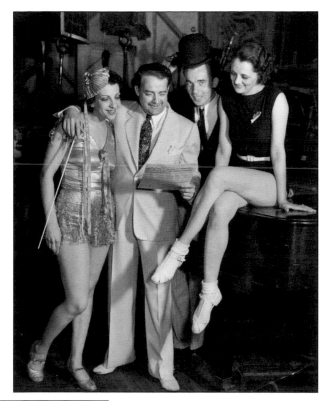

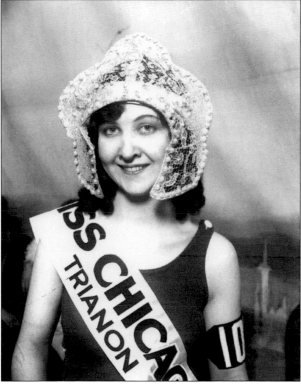

MISS CHICAGO. Big ballrooms in Chicago kept the city dancing throughout the good years and the bad. The opulent Trianon Ballroom, which opened in 1922 at 6201 Cottage Grove Avenue, could hold 1,500 couples on its enormous main floor. The crowd was mostly lower- and middle-class young adults anxious to try out the latest dance steps. The ballroom did not book jazzy bands because one could not dance to "listening" music. The Trianon was designed by the Chicago architectural firm Rapp & Rapp and was soon replicated in other cities across the United States. Over the years, it sponsored beauty contests and even had its own radio station, WMBB, where all of the country's top big bands played and were often broadcast on the air. Pictured is a Miss Chicago winner.

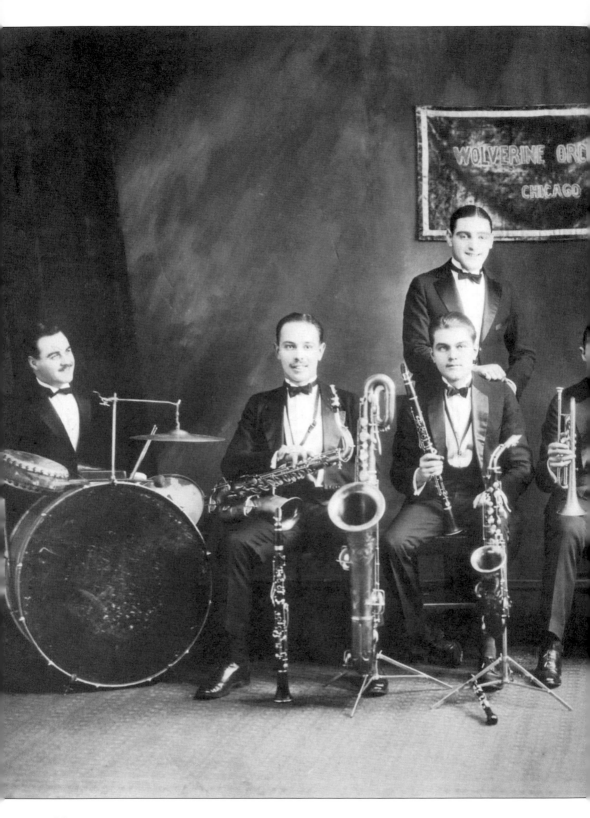

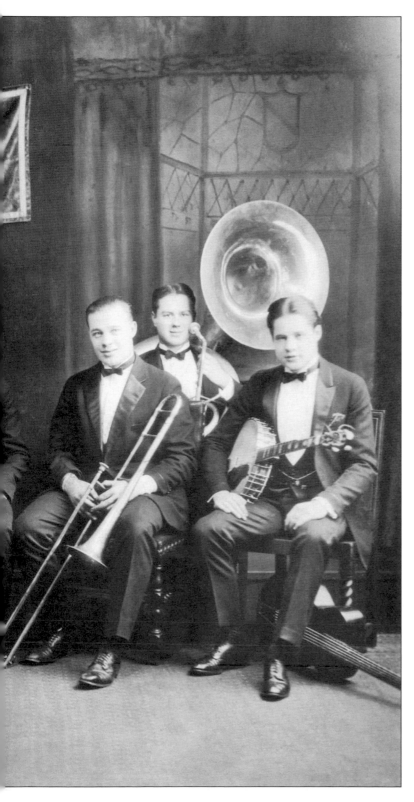

BIX BEIDERBECKE.
Stories of the great Chicago bands of the 1920s and 1930s could fill a book. Ray Bargy headed up the Benson Orchestra at the Marigold Gardens, and Orrin Tucker's band held forth at the Edgewater Beach Hotel. Paul Whitman played here too when he lived in Chicago. Whitman and bandleader Ben Bernie played at the opening of Harry Voller's downstairs nightclub Planet Mars in Chicago. The most popular jazz ensembles that crisscrossed the United States in the 1920s, playing music clubs and speakeasies, was the Wolverine Orchestra. Bix Beiderbecke (fifth from left, seated), one of the true greats, was a Davenport, Iowa, native who often visited black jazz clubs on Chicago's South Side. He moved to Chicago in 1922 and began gigging with local jazz bands immediately. The Wolverines were so profitable that one Cincinnati club owner reportedly locked up their instruments so they could not skip town. (LOC.)

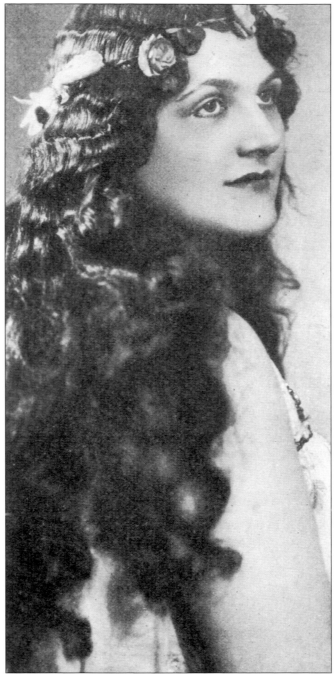

FAITH BACON. Also appearing at State-Lake Theater in 1933 and the World's Fair that year was Faith Bacon. She performed a fan dance and claimed that she, not Sally Rand, created the popular, racy performance at the fair's Italian Village exhibition. In 1936, appearing at the State-Lake Theater nude on top of a glass drum, she fell through and cut her thighs when the drum shattered. With her legs scarred, she sued the theater for $100,000. Bacon, however, did not collect, and on September 26, 1956, she jumped from a two-story window in Chicago and died with 85¢ to her name.

Six

CARTOONISTS AND WRITERS

FUNNY PAGES. There was not a more perfect place to birth and popularize cartoon characters than Chicago in the early 1900s. Rival newspapers fought it out by reporting on political corruption, sex scandals, and gangsters but found readers also wanted a break from the depressing realities of the day. Sports news, automobile talk, and the comics provided relief and were sometimes read first. The two great rival papers were William Randolph Hearst's *Chicago American* and the *Chicago Tribune*. The newspapers battled it out twice daily and hired not only artists to create front-page political cartoons but also cartoonists to fill their funny pages with strips.

CHIC YOUNG. Newspaper readers loved cartoon strips that focused on family life. Chicago artist Chic Young drew one of the best of this genre. Young graduated from McKinley High School and was nicknamed "the Chicken" in the school's yearbook. He came from an artistic family; Young's brother was a cartoonist for King Feature. Chic started working in Chicago as a stenographer while attending the Art Institute of Chicago. The Newspaper Enterprise Association in 1921 was looking for a cartoonist to do a strip about a young woman's adventures. The association hired Young for the job, who drew *The Affairs of Jane*. Later, in the 1930s, Jane morphed into *Blondie*, who was married with a boob of a husband, Dagwood, and two children. Young married a professional harpist in 1927, and when the couple lost a baby, he could not draw Baby Dumpling in his strip for a while. Chic drew an astonishing 15,000 strips, and his son, Dean Wayne Young, keeps the strip going.

SIDNEY SMITH. Chicago cartoonist Sidney Smith was a one-of-a-kind artist. Smith's cartoon family was based on an idea by Capt. Joseph M. Paterson, editor of the *Chicago Tribune* in 1911. Smith had previously worked as a sports cartoonist for the *Chicago Examiner* in 1908. His two most notable works were *Old Doc Yak*, centered on a talking goat, and *The Gumps*, which was about an ordinary family. In 1926, *The Gumps* became even more famous when Smith killed off the character Mary Gold. It was the first time a comic strip had killed off a major character. Why? Smith had been in love with a secretary named Mary Bridgemen, but when the relationship ended, Smith was inspired to remove Mary Gold from the comic strip.

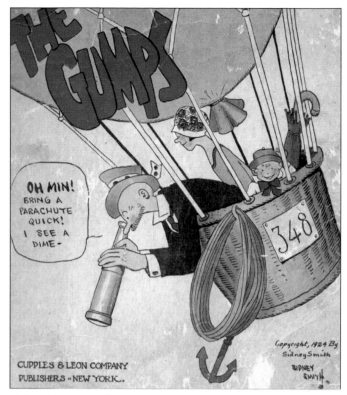

CASHING IN. Smith had a townhouse in Chicago in the 1920s. He became the first million-dollar cartoonist after signing a contract with the *Chicago Tribune* for $100,000 a year for 10 years. In 1935, his contract changed to $150,000 a year. Smith spent most of his time at his 12-room mansion on the shore of Lake Geneva, Wisconsin, where he indulged his passion for partying lollapalooza style. At these gatherings, he often wore a coonskin hat and danced around a lawn sculpture of Gump, his claim to fame and fortune. At the top of his game, Smith died in a car crash at the age of 58. This image is from an ad for the 1913 short film about Smith, *Old Doc Yak and the Artist's Dream*. (LOC.)

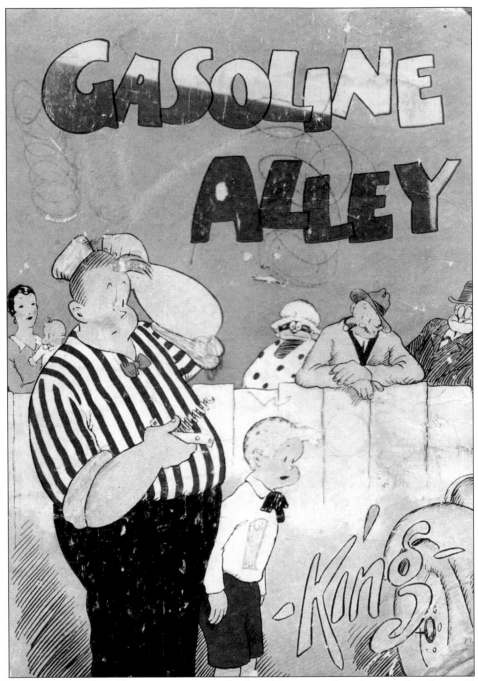

FRANK KING. Another Chicago cartoonist who based his artwork on his own family was Frank King. King went to the Chicago Academy of Fine Arts and started out working for the *Chicago Examiner* but switched to the *Chicago Tribune*. By 1912, he was earning thousands a year. In 1911, 25-year-old King married, and the main character in his *Gasoline Alley* strip, Walt, was based on King's father-in-law, and Skeezix was modeled after King's son. *Gasoline Alley* was in 300 daily newspapers and reached 27 million households. The *Chicago Tribune* paid him well, and with royalties and spin-off product revenue, his income added up to $25,000 a year.

BILLY DeBeck. Another member of Chicago's pantheon of toon artists was Billy DeBeck from the South Side. Born in 1890, he graduated from Hyde Park High School in 1908. DeBeck attended the Chicago Art Institute and got his start freelancing at the *Chicago Daily News*. His first career choice was to be a serious painter, but in 1910, he accepted a job cartooning for a Chicago weekly paper called *Show World*. DeBeck then went to work for the *Chicago Herald* in 1915. Hearst bought the paper to get DeBeck's work. DeBeck refused to work for Hearst unless he was paid more. His salary went from $35 a month to $200. He is pictured here with his wife.

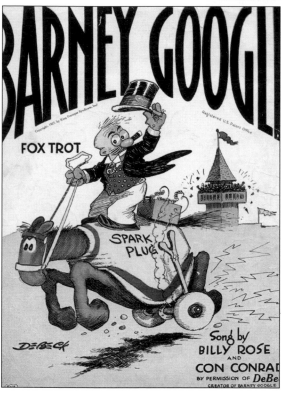

BARNEY GOOGLE. DeBeck's drawing style was revolutionary. His scratchy figures had big feet and bulbous noses, Robert Crumb like. DeBeck's strip *Barney Google* headed up the sports section of the *Chicago Herald*. Barney was obsessed with sports, and his wife henpecked him about his passion. At first, Barney was drawn tall and skinny, like Gump. DeBeck changed him to short and fat in 1922 and added a racehorse named "Spark Plug." *Barney Google* inspired a song, but DeBeck's later creation, in 1930, *Snuffy Smith*, about a lovable hillbilly, became a classic cartoon.

93

Fontaine Fox. Born in 1903, Fox was a trailblazing cartoonist who first showed his art from an elevated view. Fox first drew *Toonerville Folks* for the *Chicago Evening Post*, but it spread to 300 newspapers. Fox collaborated with Chicago's great writer Ring Lardner in 1919 on a book, *Own Your Own Home*, which poked fun at Chicago city-dwellers escaping to live in the suburbs. The *Chicago Tribune's* Frank Willard's *Moon Mullins* ran from 1923 to 1991.

Ring Lardner. Ringgold Wilmer Lardner was born in 1885 and excelled in writing sports stories, satirical tales, and dramatic skits. Lardner loved to chronicle the institution of marriage and Chicago theater goings-on. His sports column ran in 100 newspapers. He hung out with the likes of F. Scott Fitzgerald and Ernest Hemingway. Lardner, seen here in 1922, also wrote skits for the Chicago Ziegfeld Follies.

BEN HECHT. Another Chicago master-writer was Ben Hecht, who ran away from home to Chicago in 1910. His descriptions of Chicago were dramatic and raw, and "haunted streets, whorehouses, police stations, courthouses, theater stages, jails, saloons, slums, madhouses, fires, murders, riots, banquet houses, and bookshops" were all covered in his column for the *Chicago Daily News*. His screenplay *Front Page* captured the fast life in a big city and its newspapers competing for a scoop. This portrait dates to 1919, at age 25. His *1001 Afternoons in Chicago* was illustrated by Herman Rosse and artists in multiple disciplines and a design instructor at the Art Institute of Chicago. Rosse later won an Academy Award for Best Director for the 1930 film *King of Jazz*.

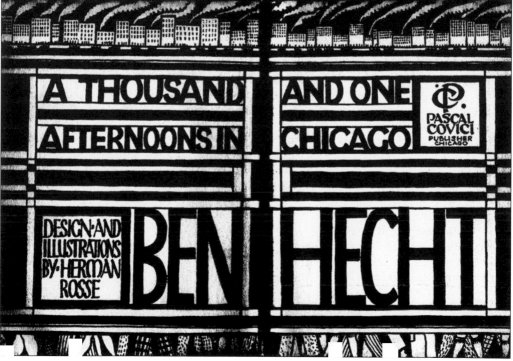

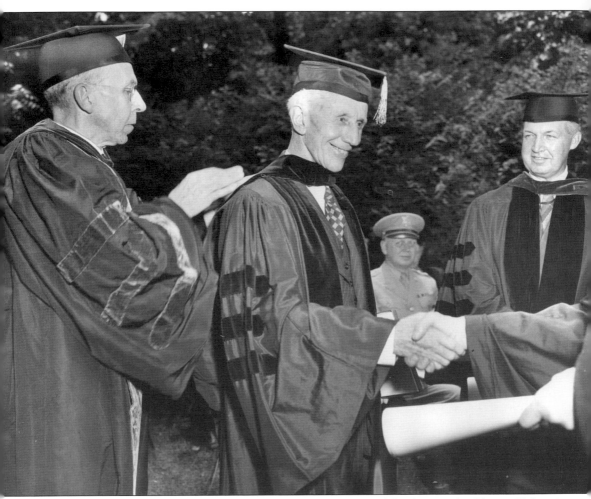

JOHN T. McCUTCHEON. One of the most popular cartoonists of the day was the *Chicago Tribune's* John T. McCutcheon. He loved to poke fun at Chicago politicians. McCutcheon is seen here at center receiving an honorary degree from Northwestern University. Other cartoonists with Chicago ties whose work became world famous include Harold Gray (*Little Orphan Annie*), Chester Gould (*Dick Tracy*), and Hal Foster (*Tarzan* and *Prince Valiant*), who biked from Nova Scotia to Chicago in 1919 to attend the Chicago Academy of Art.

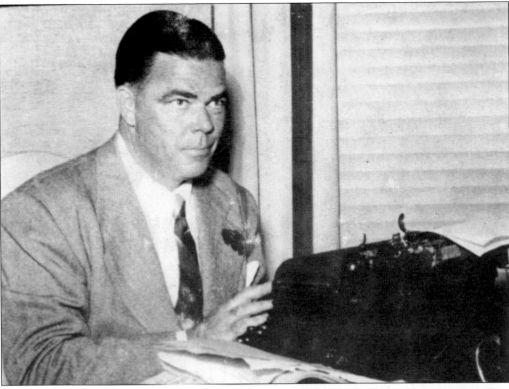

THE PROLIFIC MR. ANDREWS. Robert Hardy Andrews, born in 1903, wrote for the *Chicago Daily News* starting at the age of 21. His office mate was no less than Carl Sandburg, Lincoln scholar. Andrews was 10 newspaper men in one. For decades, he turned out not only the newspaper's weekly magazine but also his own column. Andrews wrote 50 movie scripts and numerous television shows, such as *The Millionaire*. He also wrote radio soap operas, such as *Ma Perkins*, created Wheaties logos, and found time to write popular novels. He tells of all this in his biography, *A Corner of Chicago*.

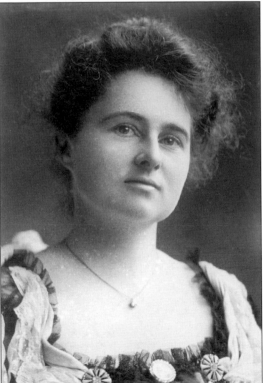

MRS. CARTER HARRISON. Wife of the five-term mayor, Carter Harrison Jr., Edith Ogden Harrison was a published author of children's books, novels, travelogues, and even an autobiography. Her novel *Lady of the Snows* was illustrated by the famous artist and teacher J. Allen St. John at the Chicago Art Institute. In 1915, Chicago's Essanay Studios made it into a silent film.

ANNA FRITZ. Many famous entertainers, once past their glory days, write books about their careers or other subjects. Chicago female opera stars, such as Mary Garden, told all in their biographies. Anna Fitziu sang with various Chicago opera companies, and in 1928, due to a two-year illness, she was back in town writing a book. She finished the book and recovered her health, but never returned to singing; writing became her true love.

Seven

WORLD'S FAIRS

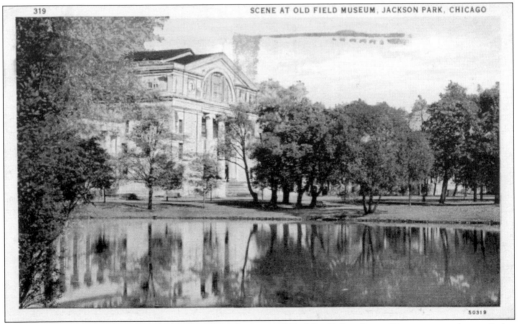

319 SCENE AT OLD FIELD MUSEUM, JACKSON PARK, CHICAGO

50319

WHITE CITY. Chicago's first World's Fair, the 1893 World's Columbian Exposition, showed the world that Chicago was up and running better than ever after the devastating fires of the 1870s. Like a phoenix, the city was reborn. The fair celebrated the 400th anniversary of Christopher Columbus's discovery of America. The majority of the buildings at the fair had a neoclassical architectural style and looked very Greek. The massive white buildings were Victorian fakery. The exteriors were made of staff, a mixture of plaster of paris, glue, and hemp fiber, painted white. Some even called the fair a White City. Never designed for posterity, the buildings later fell into disarray. One survived, the Palace of Fine Arts. By 1920, its exterior was in sad shape and was replaced with limestone; it continues to serve Chicago as the Field Museum.

Sol Bloom. No man was more responsible for making the fair a success than a Polish Jew by the name of Sol Bloom, pictured here at left in 1939. When the fair was approved by Congress, Chicago politicians moved fast to get it held here rather than somewhere else, such as New York City. Once Chicago was selected as the fair site, Bloom helped mold the character of the fair. He was a renaissance man of the first order—a writer, impresario, politician, music writer and publisher, congressman, and diplomat. He was born in 1870 and grew up in the city. He attended the Exposition Universelle of 1889 and was impressed with the swirling North African music and dances. Bloom returned to Chicago to become the entertainment director for the Chicago World's Fair of 1893. He reasoned that the entertainment that worked in Paris would work in Chicago. Sol Bloom, very much a political leader in Chicago after the fair, went to New York and turned Republican, getting himself elected to the House of Representatives for 14 terms. The belly dance man was now an FDR man. Pres. Franklin D. Roosevelt put Bloom in charge of the lend-lease program. Bloom was a delegate to the meeting in San Francisco to create the United Nations. He coined the opening to its charter, "We the peoples of the United Nations."

WHITE CITY ENTRANCE
CHICAGO, ILL.

Chicago Sept 7 08

WHITE CITY

Was out here last Sunday — Doingly Busy

GRAND ENTRANCE. Bloom planned a long entranceway to the fair, a pedestrian runway called a Midway Plaisance. The fair had 47 nations attend, and their cultures were displayed along the Plaisance. Statues and buildings inside the fair were somber and impressive. Outside entertainments featured belly-dancing in rhythm with Middle Eastern music. Also along the strip was the Hagenbeck Circus; Japanese and Indian bazaars; German, Lapland, Dahomey, and Turkish villages; "Street in Cairo"; a Moorish palace; ice runway; and Viennese café. The chief attraction was a moving sidewalk for 5¢, and the pricey Ferris wheel, which had thirty-six 60-passenger cabins. The giant wheel was not a financial success, but most other exhibitors made money. The most expensive ride at the fair was the hot-air balloon ride at $2 a customer. Naturally, as the fair was named the World's Columbian Exposition, it also featured this replica of one of Christopher Columbus's boats.

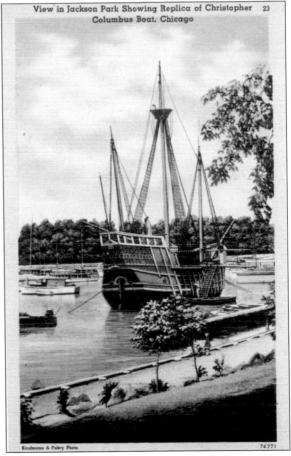

View in Jackson Park Showing Replica of Christopher 23
Columbus Boat, Chicago

Kaufmann & Fabry Photo 74771

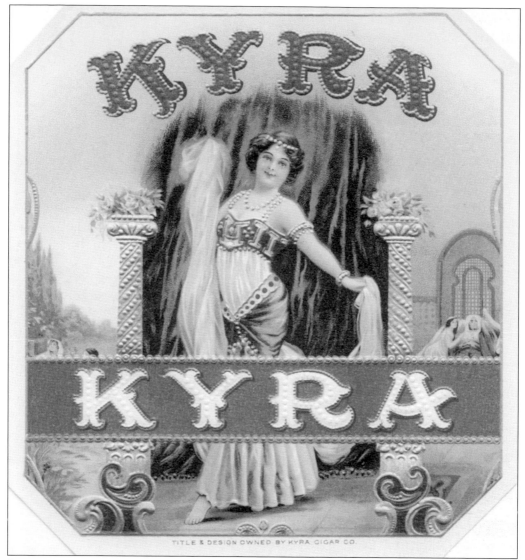

TITLE & DESIGN OWNED BY KYRA CIGAR CO.

STREET OF CAIRO. The Street of Cairo exhibit featured many belly dancers, but one drew international fame. Dancer Fahreda Mazar Spyropoulos's stage name was Little Egypt. She and her colleagues needed a theme song to dance to, and Sol Bloom came to the rescue. One day at the Chicago Press Club, Bloom went over to the piano and composed a simple little song that was destined for fame. Bloom called it "The Street of Cairo," and his sheet music publishing firm printed the song. It proved so popular that this hip-shaking, undulating music found its way into modern ballet companies' programing, as well as cigar labels. Pictured is Kyra Cigar's belly dance–inspired advertisement.

BY BRIDGE. The physical landscape of Chicago had to change to accommodate the 1893 fair. All sorts of bridges were built to speed fairgoers along their way. Some were swing, vertical lift, and jackknife. Others were doubled-decked to accommodate train tracks.

BY BICYCLE. Another popular way to get to the fair was by bicycle. Mayor Carter Harrison was a bicycle enthusiast. In 1894–1895, Annie Kopchovsky biked around the world in 15 months, passing through Chicago, where she switched to a Chicago Sterling bike.

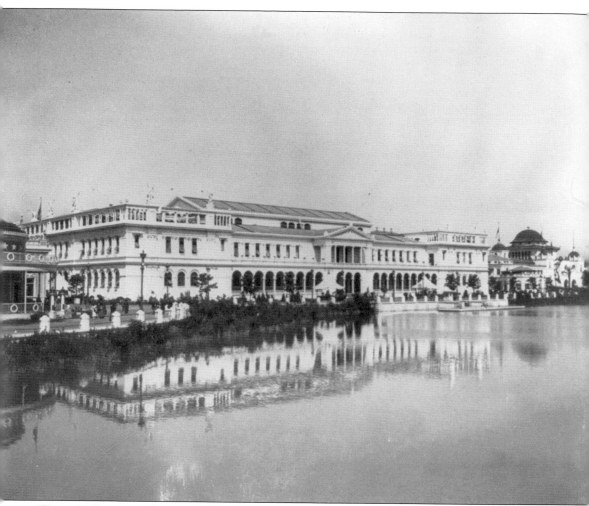

Women's Building. Women played a key role at the 1893 fair, and they demanded that their contributions to the arts be included. The Women's Building displayed their artwork and inventions. Women provided the day-to-day muscle for the fair. The building was designed by Sophia Hayden, whose design had been judged best, and the exterior and interior of the building showcased the works of the best women sculptors and artists of the day. Mrs. Bertha Palmer, called "the Queen of America," was the wife of Chicago hotel owner Potter Palmer. She and her privileged friends were made lady managers of the fair. They dictated a strict dress code for female workers at the fair: tailored coat, skirt, and shirt waist blouse. (LOC.)

IGNACY PADEREWSKI. Entertainment in downtown Chicago also drew fair visitors in 1893. Polish pianist Ignacy Paderewski played at the fair but not on the fairgrounds. The fair only allowed pianos to be played whose makers had entered a piano competition. Great piano makers, such as Steinway & Sons piano company, did not want to compete at the fair, but only to have all pianos heard, not judged. This was not the Chicago way; the city wanted a sporting event. When the judging took place, it was no surprise that Chicago's Kimball Piano Company took high honors. Florenz Ziegfeld Sr. and music critic Felix Borowski, who taught at the Chicago Musical College, were among the fair judges.

AUNT JEMIMA

AUNT JEMIMA. One of the most popular midway attractions outside the fair was a talented cook from Chicago's South Side making pancakes beside a large flour barrel for Davis Milling Company. She sold pancakes and pancake mix to take home (over 50,000 orders) and won a cooking award at the fair. Nancy Green was her name, and she became the company's first "Aunt Jemima," playing that character until her death in 1923.

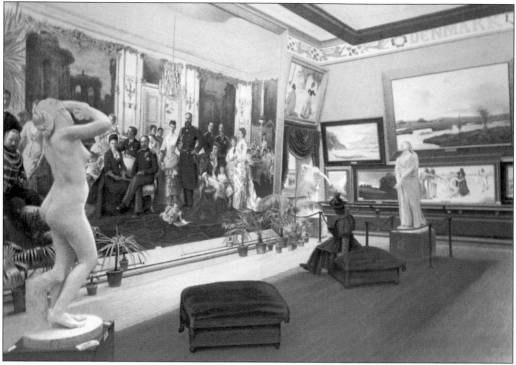

ROMANOVS ON DISPLAY. Featured inside the fairgrounds were the artwork and inventions of many nations. This painting of the royal family of Russia, the Romanovs, was displayed on the wall of Art Gallery Room No. 34 at the World's Fair. Such prominent locations in various buildings of culture were reserved for Western nations; blacks and Indians, for example, appeared only on stages, or designated villages, as mere amusements.

CRACKER JACK! Few would argue that Chicago is not the creative epicenter of snack foods. The 1893 World's Fair triggered a massive demand for quick and cheap food for its visitors. The Chicago Rueckheim brothers introduced Cracker Jack at the fair, as well as Tootsie Rolls—the first wrapped penny candy, named for the inventor's daughter's nickname.

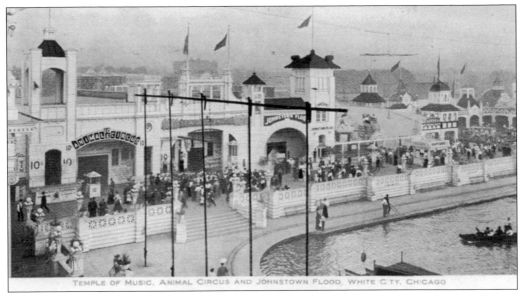

TEMPLE OF MUSIC, ANIMAL CIRCUS AND JOHNSTOWN FLOOD, WHITE CITY, CHICAGO

WHITE CITY AMUSEMENT PARK. The 1893 fair was such an economic success that the city wanted to keep the good times rolling, keep some of its attractions, dream up others, and reopen as an amusement park in the Woodlawn area on the South Side. White City opened in 1905 and was the biggest park of its kind in the United States. In the evenings, its thousands of lights could be seen for miles. The Goodyear blimp was introduced here to transport visitors from downtown to White City. The blimp was called the *Wingfoot Air Express*, but in 1919, tragedy struck. The blimp crashed into the Illinois Trust and Savings Building on La Salle Street, killing 12 people and injuring 28. The *Wingfoot Air Express* closed its Grant Park airstrip, and the Chicago Air Park was created south of the city, now Midway Airport. White City was an early Disneyland prototype in character. No doubt Walt Disney, a Chicagoan, visited here as a youth. By 1910, White City was in trouble financially; J. Ogden Armour renegotiated its lease, and it lived on.

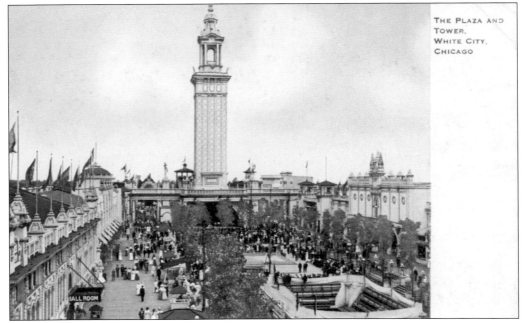

THE PLAZA AND TOWER, WHITE CITY, CHICAGO

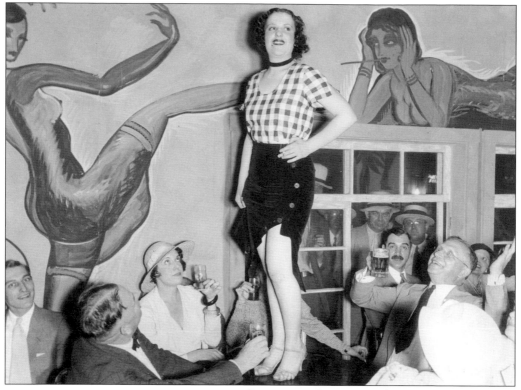

Century of Progress. The 1933 Century of Progress World's Fair proved to be a godsend for the city and a way to fight the Great Depression. The old fair had its own character; the new fair promised that prosperity was here with sleek new inventions. Belly dancers were replaced by fan and balloon dancers, and Wild West shows in Soldier Field showcased attractive cowboys and cowgirls. Products, including clothing, were streamlined with simple, straight lines. Cars, locomotives, toasters, homes, and even art turned Art Deco. As seen here, pretty girls danced on tables in beer halls to help liven things up. Less appealing to the public were the pay toilets, introduced at the fair.

MURIEL PAGE

Flame Dancer. A popular act with pizzazz at Chicago's second World's Fair was Muriel Page, billed as the "Flame Dancer." She performed alongside two almost-nude Indian maids to mix in with the flames—the fair's warped salute to Native Americans.

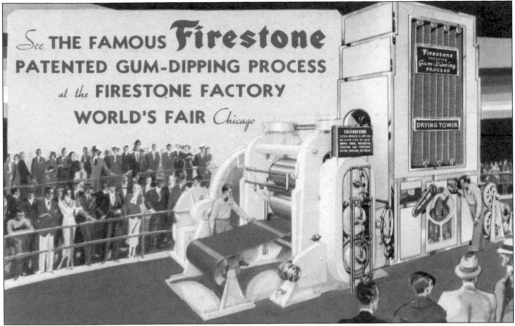

FIRESTONE TIRES. A key exhibitor at the 1933 fair was Harvey Samuel Firestone, whose father Harvey Firestone had created a tire-making empire in Chicago. Harvey Jr. was born in Chicago and acquired an important patent for tire making. At the 1933 fair, Harvey Jr. showed off Firestone's latest tire-dipping assembly line.

IDABELLE FIRESTONE. The Firestones were achievers. Harvey Sr.'s wife, Idabelle, was a musician and composer. She wrote a beautiful song, "If I Could Tell You," that was played on the *Firestone Hour* radio broadcasts across the country.

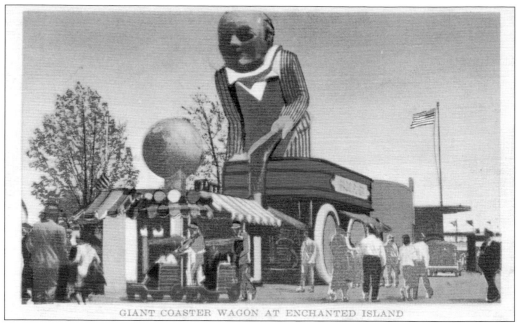

GIANT COASTER WAGON AT ENCHANTED ISLAND

RADIO FLYER. One of the most eye-catching displays at the 1933 fair was created by Antonio Pasin, the founder of the Radio Flyer wagon company. He called his red wagon a Radio Flyer hoping to attract youngsters fascinated with the radio and flying. Red, the wagon's signature color, signified speed and action. The company's giant wagon at the fair cost $30,000 to build but was an instant success. The 1930 price for a radio flyer was $4.

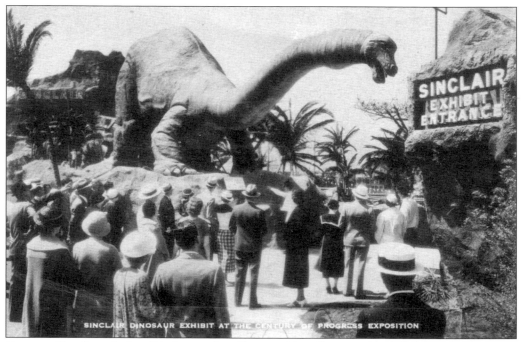

SINCLAIR DINOSAUR EXHIBIT AT THE CENTURY OF PROGRESS EXPOSITION

SINCLAIR OIL. Long before "Sue" arrived in Chicago, "Dino" captured little kids' hearts. Dino was one dinosaur of seven that were at the fair in an exhibit sponsored by the Sinclair Oil Company.

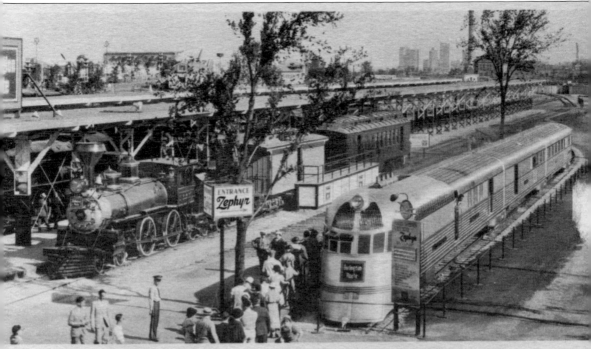

BURLINGTON ZEPHYR AT A CENTURY OF PROGRESS EXPOSITION — 1934
Built of stainless steel — Electric shot welded — Rides on articulated trucks. Powered by an eight-cylinder, two-cycle, 660 horse-power, oil-burning Diesel engine. Runs on roller-bearings — Air-conditioned — Equipped for radio reception.

ZEPHYR AND THE BURRO. Streamliner train makers were in heavy competition in the 1930s. These sleek trains had aluminum-clad cars and were driven by diesel, not steam power. The Electro-Motive Company was a mother to the diesel industry. Its famous coast-to-coast liner was called the *Zephyr* and had broken the 100-miles-per-hour barrier. The Electro-Motive Company decided to help open the 1933 fair by running a *Zephyr* from Denver to Chicago and breaking a world speed record again. The *Rocky Mountain News* in Denver wanted to join in the opening-day celebration by sending a gift to the fair on the train. The Electro-Motive Company was shocked to discover the gift was a burro, a smaller version of a donkey! The burro caused problems from the first. The trip started one hour late due to a faulty armature assembly, and when they went to replace the part, a hay-eating burro refused to move out of the way. A worker moved the burro's hind leg 180 degrees to get the replacement part installed. The train arrived at Halstead Street for a ribbon cutting, then went on to the fair, arriving at 7:10 to start a spectacular parade. Each evening of the fair would have such a parade headed by no other than the stubborn burro, now named Zeph.

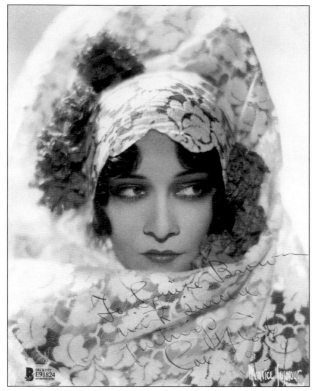

COE GLADE. Entertainers ruled at the fair. Coe Glade not only crowned horses, as seen on this book's cover, but also sang at the Hiram Walker Canadian Club in 1934. Sally Rand's feather fans moved over her seemingly nude body to packed audiences. Rand danced to the music of Claude Debussy on a blue-lit stage. In her spare time, Rand like to ride horses. Faith Bacon, another dancer at the fair, danced with flames.

FLORENCE B. PRICE. Frederick Stock conducted the Chicago Symphony in June 1933 in a performance of Florence B. Price's Symphony No. 1. It was the first time that a major symphony orchestra had played a black woman's music. Price had studied at the Chicago Musical College and Chicago American Conservatory of Music. Unfortunately, after so many exciting firsts, the fair ended on a sour note. Chicago mayor Anton J. Cermak was murdered while shaking hands with Franklin D. Roosevelt in Miami just two days before the end of the Century of Progress Fair.

Eight

RADIO, RODEOS, AND SMOKES

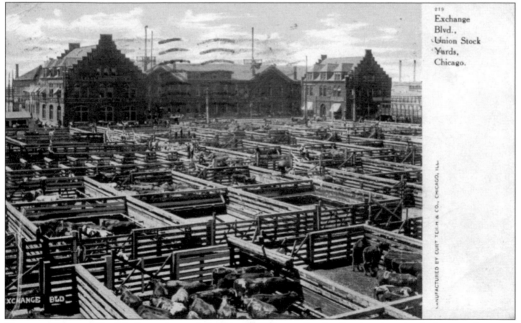

CATTLE TOWN. Native Americans inhabited Chicago in the beginning, and the area's name roughly translated to "stinky onion." Once the Natives were expelled, cowboys moved in with herds of cattle. They were butchered at Chicago's Union Stockyards and sent out to feed the nation.

SOLDIER FIELD COWBOY. These young roustabout cowboys were recast as fancy-dressed buckaroos in Hollywood films, magazines, and radio. In arenas and stadiums, reenactments of cowboys fighting Indians always ended with the cowboys, perhaps even headed by Wild Bill Hickok, saving the stagecoach and damsels from the "savages."

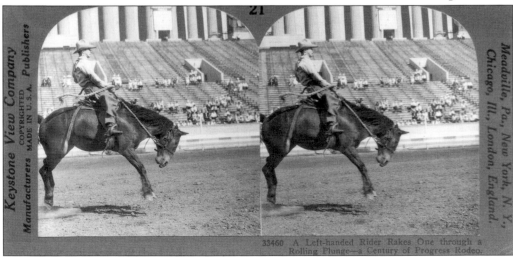

COWBOY VS. COWGIRL. A big attraction at the rodeos and Western shows in Chicago after the turn of the 20th century were fast-riding, roping, and hog-tying cowgirls. Sometimes, the cowboys and cowgirls went up against each other, proving that women were not all that delicate as once believed. If one could believe Western movies and the radio, all cowboys could sing and play the guitar—sometimes even cowgirls.

RADIO COWBOYS AND COWGIRLS. Chicago radio stations, such as WLS, offered up country music, and at one time, the WLS *National Barn Dance* ruled the airways in the Midwest and beyond. Wearing big white hats, the station's Prairie Ramblers, Chick Hurt, Jack Taylor, Tex Atchison, and Patsy Montana, fiddled and sang their way into American hearts. It all started out for these country music stars in 1933 when Ruby Rose Bevins and her two brothers came to the World's Fair to enter their watermelon in the judging. Whether or not her watermelon won is unimportant. What was important was that she got to sing for the managers of WLS and BAM. They liked her and the Prairie Ramblers. The group soon became a popular WLS program. Ruby Rose changed her name to Patsy Montana, and frequent singers who sang with her included Roy Rogers, Gene Autry, and Red Foley. Montana recorded often and became the first female country music star to sell a million records and enter the Country Music Hall of Fame.

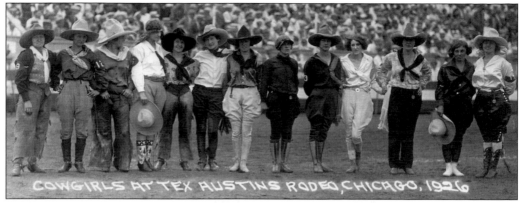

SOLDIER FIELD RODEOS. WLS eventually built large studios at 441–445 North Michigan Avenue. Studio 1 at WLS held 600 people for live broadcasts. Gene Autry appeared on the *Barn Dance* for four years in the 1930s but left town when his new restaurant burned to the ground from not so mysterious causes. Autry had refused to pay local mafia bosses their cut. Cowboy six-shooters were no match for machine guns in Chicago! Radio shows and Western movies drummed up business for yearly rodeos at Soldier Field by such groups as Tex Austin's Rodeo. These rodeos were family friendly, and Ken Maynard, Cisco Kid, and Gene Autry headlined at some of the shows.

DAN RUSSO. Among the many bands that played at the Oriental Gardens, located 23 West Randolph Street in Chicago, was Dan Russo and his Orioles. The music was broadcast over six stations throughout the week. Russo's band was heard on WMAQ and KYW on Sundays, and on WERN, WLS, and KYW on other days.

DAN RUSSO

and his

ORIOLES

BROADCASTING SCHEDULES

OVER STATIONS

W M A Q Daily 12.45 P.M.

W E N R - N. B. C. Daily 6.15 P.M.

W E N R Daily 12.30 A.M.

W M A Q Sunday 6.30 P.M.

W L S Tues. Wed. Sat. 7 P.M.

K Y W Wednesday 7.45 P.M.

Wednesday, Friday and Sunday 11.30 P.M.

The Oriental Gardens

23 W. Randolph St., CHICAGO

A WORTH WEIL SONG

NIGHTY NIGHT DEAR

WORDS & MUSIC BY
JOE L. SAUNDERS
& PAUL ASH

WALTER WILSON "UNCLE BOB"
WESTINGHOUSE STATION KYW
CHICAGO.

MILTON WEIL MUSIC CO. INC.
54 W. Randolph St., CHICAGO

UNCLE BOB. Westinghouse's Radio KYW in Chicago featured an early children's show called *Uncle Bob*, voiced by Walter Wilson. Later on, Chicago had many other men and women as hosts of before- and after-school radio shows. Chicago radio stations, such as WBNN, had their own orchestras that played a wide variety of music, from classical to popular. WENR's orchestra leader was Frank Westphal.

BURGER TIME! With Chicago's stadiums and parks filled with baseball, football, music events, and rodeos, there needed to be quick food and drink available. Cheap bottled beer was not a problem, but how could vendors produce a hamburger for 5¢? At the beginning of the century, hand-cranked wooden hamburger presses were cheap but slow. Harry W. Holly was a laid-off ironworker in 1930 who went into business underneath his grandmother's front porch in Calumet City. He sold hamburgers, pie slices, and coffee for 5¢ each. He, too, used a wooden hamburger press, nicknamed "Old Woodie," but by the 1930s, he turned to a metal press. His metal press, eventually automated, produced the standard size for hamburgers—21 millimeters high and 120 millimeters wide. His company was first known as Holly Molding and located at 6733–6735 South Chicago Avenue. The company is still in business.

5¢ SMOKE. Besides Chicago's need for a 5¢ hamburger, there was a need for a good 5¢ cigar. From 1893 to the start of the 1920s, the cigar industry in Chicago was booming. Cigar-making was a demanding process. Rolling by hand in factories and homes, men, women, and children provided the labor force. The Polish community had a cigar manufacturer, Val W. Poterek and Sons, with Revolutionary War hero Casimir Pulaski on their label. There was even a Marshall Field cigar, and John B. Grommes, Nathan Elson, and Andrew Kennedy made cigars together until Elson took over and built a factory on Damen Street. The cigar was called Ben Bay. La Patura cigars were made in Chicago by Meyer Patur.

JAMES W. SCOTT. Chicago's most famous cigar maker was also a newspaper owner and politician. James W. Scott started out as editor of the *Chicago Herald* in 1881, and by 1895 controlled the *Times Herald* and *Evening News*, all Democratic papers. His cigar company had his picture in color-lithography on the box, inner label, and band, making him one of the city's most recognizable men about town. Scott's greatest feat was to use his influence to persuade Congress to vote funds for a World's Fair in 1893 and to make Chicago, rather than New York City, the winning site.

SELLING SMOKES. The movies and radio embraced the use of tobacco. Cigars and pipes gave way to cigarettes, which, by World War I, became the quicker and easier way to light up. Famous people went on the airways to endorse one brand over another. These included CBS radio singer Vaughn Monroe and Jo Anne Johnson, seen above, and orchestra leader Herbie Kay, at right. Opera singers said cigarettes soothed their throats and relaxed them!

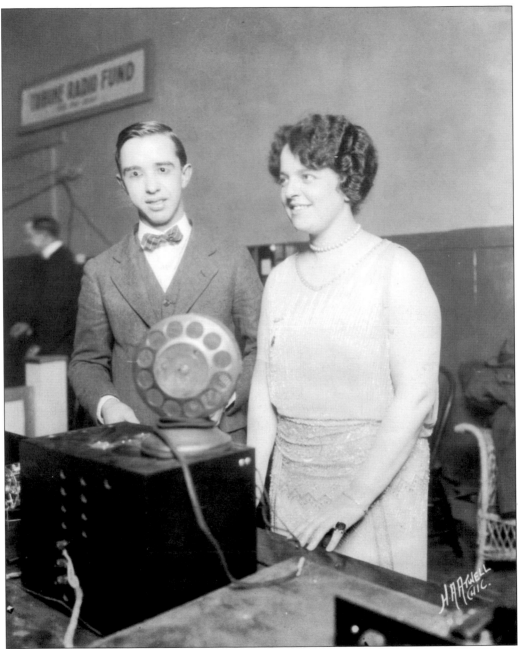

WORLD'S FINEST! Chicago claimed to have the "World's Finest Radio Singers" in the 1920s. A special jury of radio musical experts listened to each entry in a contest sponsored by the Radio Manufacturer's Show Association, located at 127 North Dearborn Street. The 1924 contest was won by Edith Bennett. She is introduced over the radio here by WMAQ chief announcer Whitney (first name unknown), who described her as "pretty and vivacious."

Amos 'n' Andy. An early NBC-WGN Radio show in Chicago that was popular in the 1930s was the *Amos 'n' Andy* show. Freeman Gosden and Charles Correll, both white, played black characters facing life's everyday problems during the Depression years—no money, no jobs, no future. The program first hit the airwaves in 1926 as the 15-minute *Sam 'n' Henry* show. The show, renamed in 1929, was one of the nation's most popular radio comedies and ran for eight years.

OPERA ON THE RADIO. In 1921, Mary Garden inaugurated the era of opera on the radio, performing on air from Chicago. (LOC.)

FRONT PORCH CHICAGO. The 1890s through 1930s were also a time when Chicago was rooted in family, and the front porch of the family home was the gathering place; rocking chairs and swings were mandatory. Photographing inside the home was nearly impossible due to poor lighting. People usually referred to their camera as the "Kodak" (though there were other brands), and with the introduction of the pocket folding camera, they now had the means to create photographs on a massive scale.

EARLY PHOTOGRAPH. While most of these homemade photographs seem boring and unartistic, like primitive paintings, some were worthy of note. A boy on a tricycle, wagon, or pony was a common photograph parents took. This photograph of a boy on a tricycle looks into his very soul.

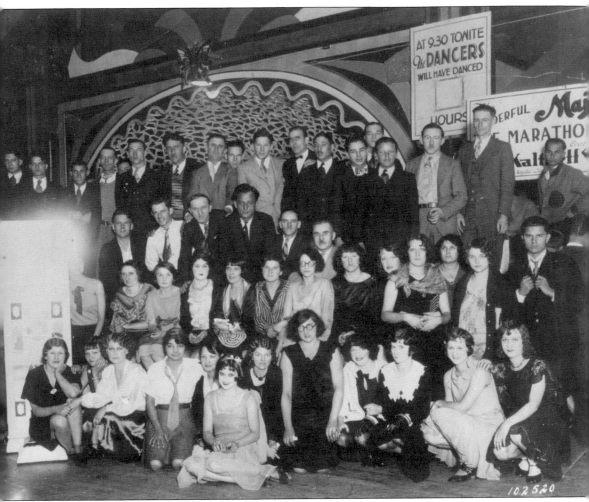

DEPRESSION-ERA DISTRACTIONS. The late 1930s were not happy years. Lollapalooza days were replaced with frantic efforts to get people out of their homes. Workers feared for their jobs, industry sought recovery, and youths were out of work. Chicagoans worked hard to find happiness at marathon events, such as flagpole sitting, bike marathons, plane races, and dance 'til you drop contests. Radio stations liked to broadcast local marathon dance contests with all their drama on the trail to a winning couple. Newspapers published photographs of the contestants as they hoofed their way to glory. The dancers were not having fun by any means; over time, dancing became torturous work. But the winners enjoyed a short moment of fame.

DANCE 'TIL YOU DROP. The paying audiences at dance marathons cheered on their favorite couple. The contests may or may not have been rigged, and usually lasted for about a week. This lady's partner has fallen asleep during a 1930 dance marathon at Chicago's Merry Garden Ballroom. Such fads faded as the nation worked its way out of the Depression, and Chicago fixated on military preparedness and eventual world war. Over the decades between its World's Fairs, Chicago acquired its personality—a land of continuous lollapalooza! (LOC.)

Discover Thousands of Local History Books
Featuring Millions of Vintage Images

Arcadia Publishing, the leading local history publisher in the United States, is committed to making history accessible and meaningful through publishing books that celebrate and preserve the heritage of America's people and places.

Find more books like this at
www.arcadiapublishing.com

Search for your hometown history, your old stomping grounds, and even your favorite sports team.

Consistent with our mission to preserve history on a local level, this book was printed in South Carolina on American-made paper and manufactured entirely in the United States. Products carrying the accredited Forest Stewardship Council (FSC) label are printed on 100 percent FSC-certified paper.

MADE IN THE USA